THE ART OF
SCRAPERBOARD ENGRAVING

THE ART OF
SCRAPERBOARD ENGRAVING

Cécile Curtis

B. T. Batsford Ltd London

© Cécile Curtis (1988)
First published 1988

ISBN 0 7134 56965 /-

Typeset by Lasertext Ltd., Stretford, Manchester

Printed in Great Britain by The Bath Press, Bath

for the publishers B.T. Batsford Ltd
4 Fitzhardinge Street, London W1H 0AH

CONTENTS

Acknowledgements 7

Introduction 9

1 Engraving: from cave walls to scraperboard/scratchboard 11
Prehistoric engraving
The woodcut and wood engraving
Scraperboard/scratchboard engraving
Some prominent exponents of the new medium

2 Tools of the trade 21
Choosing the board
Engraving tools
Special pens
Other equipment
The craft kits

3 Technical application 28
The importance of light
Textures
Black or white board?
Portraiture
Buildings and landscape

4 Step by step on black board 63
The working drawing
Preparing the board
Tracing and transferring the design
The engraving

5 Step by step on white board 71
Preliminary pencil study
Tracing and transferring
Inking
The engraving plus pen and ink
Other examples in preparation

6 The addition of colour **79**
 Experimentation

7 Tricks of the trade in illustrating **88**
 The expedient of the cast shadow
 Psychology of composition
 Points of view
 Black on white versus white on black
 Extensions and overlays

8 Other uses **111**
 Art in industry
 Commemorative medallions
 Advertising art
 The super realists

9 Further examples **131**

 Postscript **147**

 Bibliography **148**

 Suppliers **150**

 Index **151**

ACKNOWLEDGEMENTS

There are so many individuals who have helped in the preparation of this book and I am pleased to have the opportunity to thank them all 'officially'.

I am indebted to these publishers for their permission to reproduce illustrations from their books: J.A. Allen; The Bodley Head; Jonathan Cape; André Deutsch; Victor Gollancz; Hodder & Stoughton; Muller, Blond & White, and also the fine arts publishers, Felix Rosenstiel and F.J. Warren, for permitting me to reproduce their prints of my work. Thanks also to Harry N. Abrams for the quotation from *The Art of the Print*.

For allowing me to reproduce the work I did for them, my thanks go to The Newcomen Society in the United States and its president, Charles Penrose, Jr., R.H. Technical Industries, Rotomobility, and Spode, a division of Royal Worcester, especially to Robert Copeland for his expert technical description.

I am grateful to Cordon Art, representatives of the M.C. Escher Heirs, The Mansell Collection and the Tryon Gallery, trustees of the estate of Charles Tunnicliffe for granting me permission to use the work of other artists.

I must thank Graham Altuccini for his kindness in helping with the section on advertising, and the artists Allen Fisher and Philip Gale for allowing me to include their work, also *A la Carte* magazine and John Dewar & Son for their kind permission to reproduce them.

I am also indebted to these art suppliers for providing useful information as well as the loan of pictorial material: Arthur Simons and Mrs. A.E. Froggatt of British Process Boards; Andrew Cooper of Dryad; Jason Jeffries of Faber-Castell; Martin Lawrence of T.N. Lawrence; J.F. Yeomens of Oasis Arts and Crafts Products; John Oldfield of Reeves; Alan Crouse of Rotring U.K., and L.J.C. Forsythe of Winsor & Newton.

I am extremely grateful to these librarians who through their tireless efforts assisted me so much with research and sorting through all those 'B.N.Bs': Mary McIntosh and John Boughton at Mitcham, Karen Moore at Westminster and, as on previous occasions, Patrick Hillman at Wimbledon.

My thanks as well to Olive Tallick for her excellent typing of the manuscript, and the photographers at Irongate Studios and The Print Place for their splendid efforts in getting my artwork 'camera ready'.

A note of appreciation also to Tim Auger and Alison Bolus at Batsford for their patient and reassuring answers to all my queries.

I must not forget the help provided by friends: Trevor Dean of Image Promotion for his practical advice; Wendy Jakeman for taking time off from her busy schedule in Australia to send me much needed information; my dear friend Max Pohla for his perseverance in searching through the book shops of Amsterdam for that special volume on M.C. Escher, and my thanks also to Donald Skillings for the loan of 'Sadie'.

I am particularly grateful to my sister, Madeleine Fleitas, for her dedication in sorting out the profusion of illustrations from her side of the Atlantic, and to her friend, Dorothy Sheffield, for her kindness in transporting them to London.

Finally, a special word of appreciation to my mother-in-law, Emma Curtis, for her support and enthusiasm, and last but not least, to my lovely daughter Lisa for her patience in posing for me on so many occasions, as well as the forbearance of them both when I was not able to spend as much time with them as I should have liked.

INTRODUCTION

Having specialized in scraperboard/scratchboard for many years, I have grown accustomed to the puzzled expressions which the statement of this fact invariably produces!

Scraperboard/scratchboard (British and American terms respectively) is a stiff card coated with a thin layer consisting mainly of hardened china clay. Although there are different types of 'textured' boards, the two most commonly used are smooth white, upon which all shaded areas must first be painted in solidly with drawing ink, and smooth black, which is already inked over the entire surface. In the former, the shading is scraped out in varying degrees leaving some pure black. In the latter, the main outlines must be indicated with fine white lines, areas of pure white being scraped out completely, and darker tones to a lesser degree.

I first became attracted to the medium when I saw a small advertisement in an artist's magazine for 'Austrian scratchboard'. I had long admired the dramatic wood-engravings of artists like Fritz Eichenberg whose superb work lent a poetic beauty to the gloomy prose of Dostoyevski. It seemed to present a wonderful opportunity to produce a similar effect without the cumbersome and exacting limitations of engraving on wood.

In the following pages we shall be exploring the various applications of scraperboard/scratchboard as well as my own personal approach and experiments. Full descriptions and demonstrations of a variety of tools and step-by-step illustrations show the progressive stages of the work on both black and white surfaces. The introduction of colour is explained with examples and the individual interpretations of different exponents of the medium are discussed.

Scraperboard/scratchboard has been employed in one form or another in several countries for over a century. It has appeared in books, magazines, newspapers and, in a very mechanical style, for advertising in order to use a more practical and cheaper manner of reproduction and is still preferred by many advertisers as it produces the sharpest picture on newsprint.

With the development of printing methods, a half-tone black and white original now costs only slightly more to reproduce than pure line techniques. As a result, scraperboard/scratchboard, as well as being ideally suitable for black and white illustrations, is now a fine arts medium for its own sake, a status which is well deserved. Indeed, just in the past two years it has become a form of artistic expression within the scope of

enthusiastic amateurs as well as professional artists, with the advent of 'craft kits'. These provide a pre-printed design that needs only to be scraped away to produce an attractive and unusual picture. Just as the 'painting-by-numbers' kits encouraged those with artistic abilities to create their own personalised paintings, this new product, besides being an enjoyable leisure pastime for all, is engendering an interest in what is for many aspiring artists a new medium.

NB All drawings are by the author unless otherwise stated.
Dimensions in the captions apply only to the size of the image itself on white board rather than that of the board on which it was done.

1 ENGRAVING: FROM CAVE WALLS TO SCRAPERBOARD/SCRATCHBOARD

The Theologian and the poet might agree that "In the beginning was the word"
but the artist would state categorically: "In the beginning was the image"; and
it would be difficult to refute him.

Fritz Eichenberg *The Art of the Print*

Prehistoric engraving

As scraperboard/scratchboard is a comparatively recent form of graphic
expression, its history must obviously be brief. It seems appropriate,
however, to allow a fleeting glance at the background of engraving
techniques in general. In order to attain a fair assessment, one must go
back some 30,000 years to the very earliest evidence of the craft found in
the awe-inspiring creations of Paleolithic man at the dawning of *Homo
Sapiens*. Not only their cave paintings, bas-reliefs and statuettes, but also
engravings on soft stone, clay, bone and ivory, executed with such delicate
artistry and sensitivity, belie the primitive tools which were employed.
These are the handiwork of men who knew the mammoth (1) as intimately
as the horse, and placed patterns of their hands, identical to our own, like
signatures on the cave walls.

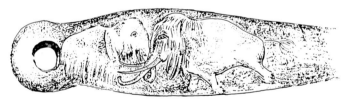

*1 Pierced staff
made from reindeer
horn similar to the
earliest decorated
example found,
circa 20,000 years
BC. Engraving shows
two facing
mammoths. Believed
to have been used as
a straightening tool
in the making of
spears, harpoons
and shafts of wood*

The majority of finds have thus far been in Europe with a particular
proliferation in southern France and northern Spain. Even the most
accomplished artist cannot fail to view these Early Stone Age art galleries
with a certain sense of humility and the realization that the evolutionary
journey from Lascaux to the Louvre, or from Altmira to the Prado, does
not seem such a long one after all.

The woodcut and wood engraving

Man continued to engrave on a variety of surfaces which, in ensuing epochs, included metals. The incised lines of a process called *Scraffito* were a method of decorating earthenware which is still used by primitive societies today. Woodblocks in a very simplified form were cut for the purpose of printing on fabrics by the ancient Egyptians in the second century BC.

The woodcut as we know it today made possible the first printing of both pictures and writing, the earliest records of which appeared in Buddhist scriptures in the ninth century AD.

The techniques employed in scraperboard/scratchboard have their origins in the woodcut and, more especially, the wood engraving. In both methods of reproducing an image the design is done in reverse on special types of wood into which it is cut or engraved, so that when the surface is coated with ink, only the untouched areas which stand out in relief will be printed. These include even the most minute dots or lines.

With Gutenberg's invention of the printing press in the second half of the fifteenth century, the woodcut really came into its own. Skilled craftsmen interpreted the masterly work of artists like *Albrect Dürer* (2), painstakingly removing all but the fine black lines which he had initially drawn upon the block, thus emulating pen and ink. These were actually black-line woodcuts. Generally, however, although there are some which closely resemble wood engravings and vice versa, the woodcut is of necessity a coarser medium, the areas of light being cut or gouged out from a side-grained block of plankwood, usually pear. The typical interpretation was, and still is, a bold pattern of white on black with varying degrees of finer white lines.

As greater refinement and detail emerged using white lines on black, the technique of wood engraving inevitably evolved. By the end of the eighteenth century it had become an important medium thanks to the efforts of the English engraver *Thomas Bewick* (1753–1828), who pioneered the use of the far more sympathetic surface of end-grained boxwood using gravers and other delicate tools similar to those employed in copper engraving. His little vignettes of the rural scene have great charm and intimacy (3). To him and to the other outstanding engravers who followed him we owe an enormous debt for the development of the technique of scraperboard/scratchboard as a new form of graphic expression. These were creative artists as well as craftsmen who engraved their own designs, developing and embellishing them in the process. With great inventiveness they expressed the varied 'greys' of a half-tone using many permutations of lines, both straight and curved, dots, dashes and cross-hatching to interpret different textures, as well as distance, with dramatic effect.

The industrial age in the nineteenth century produced an ever-increasing demand for illustration. New methods of printing by machine required

2 (opposite) Albrecht Dürer (1471–1528), The Apocalypse. A fine black-line woodcut which resembles a pen and ink drawing (The Mansell Collection)

3 *Thomas Bewick (1753–1828), wood engraving from the* History of Quadrupeds, *published 1800. One of his many fine studies of wildlife, shown in the size in which it was reproduced in the book, exemplifies the similarity to scraperboard/ scratchboard technique (Original in the Mansell Collection)*

wood-engravers to turn paintings and black and white half-tone media into line as the woodcutters had done in a more elementary way before them.

A notable artist of this era whose prolific output was reproduced in this manner was the Alsatian-born *Gustave Doré* (1832–83), whose early success in Paris was only exceeded by the enthusiastic reception he received in London during the 1860s. His greatest works were engraved by H. Pisan (4) and both their names appeared at the bottom of the prints. A new electrotype process made it possible for these wood blocks to be duplicated indefinitely and printed in many countries.

Lithography, etching and steel engraving were also employed at the time though these could not be printed simultaneously—a distinct disadvantage. Eventually the camera was able to transfer artists' work to the wood block, and later a metal plate, with greater accuracy. As the thin plate was nailed to a block of wood exactly the same height as that used for type face, the two could be printed together. Using applications of acid, the process line block came into use applying the principal of relief printing as in wood engraving, but without the necessity to make time-consuming copies in line. The metal most frequently used was zinc which, although not as fine and durable as copper, had the advantage of being less costly.

4 *Gustave Doré (1832–83), wood engraving.* The Haunt of the Deer *illustration for* Atala *by Chateaubriand (L. Hatchette, London and Paris) reproduced in* The Art Journal, *Vol. II, 1863. This highly detailed landscape in North America depicts: the splendours of her most majestic scenery and the loveliness of her pathless forests. One of Doré's more idyllic subjects*

These were known as 'zinc etchings'. Of course the blocks of that time could only convey black and white with no fine variation of shading techniques so there was still handwork involved using an instrument to create dots of varying density besides the solid blocks.

Experiments were made with drawings done on enamelled paper which then had to be embossed with a fine pattern of lines on which shading in pencil could create tones; but again, it was a very laborious answer to the problem.

Scraperboard/scratchboard engraving

All of these difficulties were resolved by the development of scraperboard/ scratchboard, not yet as an art form, but merely to produce an image for mass printing which expressed not only line, but tone. The first version, introduced around 1880 by blockmakers in Vienna, Paris and Milan, was a cardboard coated with hard wax and chalk which could be embossed with a grained pattern. This was then either painted in with India ink on the areas to be shaded or covered with black over its entire surface. The lines expressing subtle changes in shading, or areas of pure white, could be incised, scraped or engraved. Subsequently, this was easily photographed onto a metal plate and provided the necessary line block (*5a & b*) for the printer.

5a Zinc etching (actual size)
5b The print made from it (Newcomen Society publication)

The earliest form of scraperboard/scratchboard in Europe had already developed from an experiment by an English photographer, David Dickson of Lowestoft. After applying India ink to glass, he scraped it away as a method of retouching photographic plates. This led to his invention of a special cardboard-based surface embossed with hard wax and coated with chalk and a photographic emulsion. Thus a new medium for artists came into being. The Dickson family is still associated with scraperboard/scratchboard (trade marked: ESSDEE) and their company, British Process Boards Ltd., in Sheffield is the principal manufacturer where every board is the personal responsibility of Mr Arthur Simons.

A type of black board very much like that currently in use was produced in Vienna in 1906, though it was much thicker, while at about the same time Charles H. Ross came out with a similar product in the United States, where 'Ross boards' are still available today.

Besides giving a greater ease in executing the drawing, scraperboard/scratchboard eliminates the necessity of working in reverse, as in other forms of engraving, and has the considerable advantage of enabling the artist to work on a much larger scale. The original artwork (6a) can then be photographically reduced to the desired size for reproduction which, within reasonable limits (6b), enhances the delicacy of line and costs no more to print than the crudest black and white drawing.

6a Illustration of an African elephant in scraperboard/scratchboard for my book, He Looks This Way (Frederick Warne and F.J. Warren, art publisher) was reproduced in its original size, 350 mm × 280 mm (12 in × 11 in) for a fine arts print and reduced to greetings card (see front jacket), postcard and gift enclosure card sizes (6b).

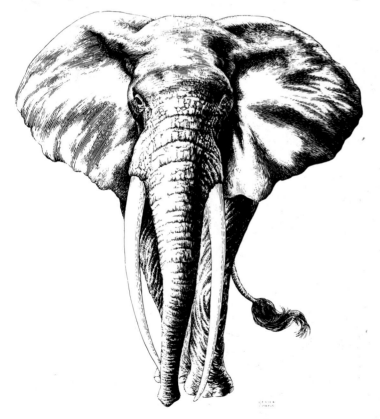

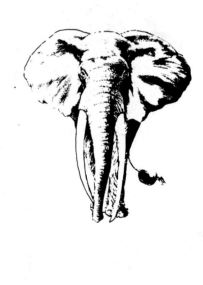

Some prominent exponents of the new medium

Despite all its obvious advantages, work in this medium appeared infrequently until the mid 1920s, and artists who wished to obtain it often had to create their own versions.

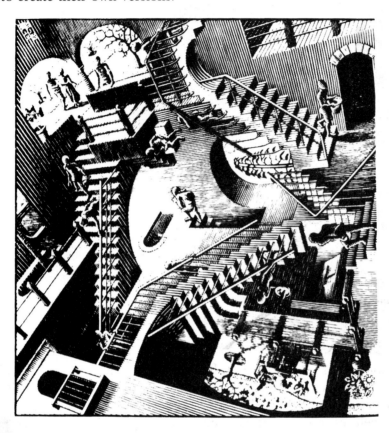

7 *M.C. Escher (1898–1972), woodcut,* Relativity, *1953, one of his puzzling perspectives. An unpublished trial print from* Der Zauberspiegel des M.C. Escher *by Bruno Ernst (Taco, Berlin). Parts of this incredible composition can be viewed equally well from the right-hand side or upside-down!* © *M.C. Escher Heirs c/o Cordon Art, Baarn, Holland*

One of the most outstanding of these was the remarkable Dutchman *Maurits Cornelis Escher* (1898–1972), a master of *trompe l'oeil* whose unique visions were so skilfully interpreted in lithographs, woodcuts and wood engravings, beguiling the eye and mind with their interlacing images or puzzling perspectives. The latter were even adapted to a cinematic presentation in the film *Labyrinth* in a dazzling three-dimensional construction. With his particular ability to engrave intricate as well as startling designs, the possibilities of the medium of scraperboard/scratchboard must have been intriguing, as a study of his woodcuts (7) and engravings would suggest. By applying Indian ink to a hard, thick flint-glazed card which then had to be dried very thoroughly before any scraping or cutting could commence, a brilliant effect was achieved, though he found that fibres were at times picked up with the sharp point of a scraping tool.

A Royal Acadamician who excelled not only in painting, etching and wood engraving, but equally in scraperboard/scratchboard, was the

'country artist' *Charles Tunnicliffe* (1901–79). His enchanting pictures in this medium of the British countryside, farm animals and wildlife, with an emphasis on birds, embellished dozens of books amongst the prodigious number he illustrated, as well as some advertisements and magazines. During the war years when boards were virtually unobtainable, he also made his own. It is often difficult to distinguish between his wood engravings (8) and scraperboard/scratchboard drawings (9). Thankfully, the latter, being much quicker, enabled him to accept a great many more commissions in black and white and this enriched the world of contemporary illustrations with his bold but detailed technique, wholly naturalistic rather than stylized, and utterly delightful.

Amongst scratchboard artists in the States of extremely high calibre have been the Rosa brothers whose classical fine 'woodcut' techniques are particularly notable. The two Walters, Kumme and Cole, outstanding masters of portraiture (the latter using the multiple tool to great effect), as well as the striking style and versatility of Merritt Cutler are commendable examples of the American contribution to the medium, together with the superb wood engravings of Fritz Eichenberg already mentioned, which must have been an inspiration to many.

9 *Charles Tunnicliffe (1901–79), scraperboard/ scratchboard,* Widgeon, *for* Farmer's Weekly *from* Portrait of a Country Artist *by Ian Niall (Victor Gollancz). (Courtesy of the Trustees of the Estate of Charles Tunnicliffe)*

In Britain the list is a long one too. The artistry of Stanley Herbert, T.L. Poulton, James Lucas ARCA, MSIA and C.W. Bacon MSIA spring to mind as leading exponents in a traditional and classical approach, their work rivalling the finest wood engravings in delicate and painstaking detail and consumate artistry.

Of course every artist should develop a unique style through experimenting, thus forming an individual approach to a given subject and finding personal preferences. However, a study of the work of different artists whom one admires can be rewarding, having at least a subliminal effect upon one's eventual artistic identity.

2 TOOLS OF THE TRADE

Choosing the board

Whether you wish to work on black or white board, it is advisable to select one of the smaller ones to begin with. There are, in fact, various trial packets available which include a few of each, the smallest of these being 152 mm × 102 mm (6 in × 4 in) and going up to 241 mm × 152 mm (9½ in × 6 in). A full sized board is approximately 610 mm × 500 mm (24 in × 19¾ in) which is also supplied in halves and quarters. Scraperboard/scratchboard is coated with hard white chalk or china clay to a depth of at least 140 microns (6 thousandths of an inch). If you are purchasing an entire sheet, your first problem is to get it home intact! It is essential that it be well wrapped and protected on both sides, with the reinforcement of some sort of heavy cardboard as the very brittle surface can crack and corners are easily broken.

There are four finishes: besides plain black or white, it is produced in a special white or grey 'suede', both plain and grained, which is used principally for medical illustrations as this surface photographs extremely well. In addition there are the grained and stippled varieties in both black (*10*) and white which are not so readily available. These are used mainly for commercial illustration work and will be discussed in Chapter 3.

10 Textured boards: 22A, coarse irregular grained stipple; 15A, fine, sand-grained stipple; 18A, 16A, 19A, cross-embossed screened; 17A, diagonally screened, all on black. ESSDEE Scraperboards/scratchboards (British Process Boards)

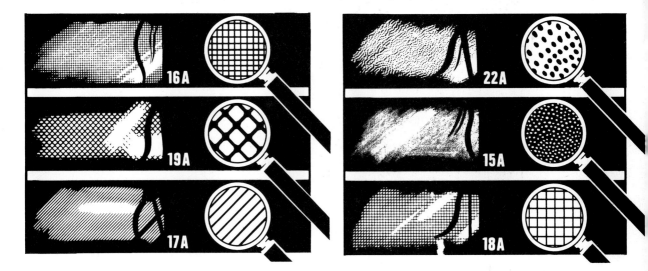

Whatever your choice, the material must be kept clean, free of scratches and, above all, completely dry as it is extremely hygroscopic and a damp atmosphere will render it useless until thoroughly dried-out again in a warm place.

Engraving tools

There is a bewildering variety of these, some made specifically for the purpose, which fit into a pen holder (*11*), although there are artists who prefer those which were made for some other use. Amongst the latter are surgical scalpels, dental tools (an unpleasant trip to the dentist can be otherwise rewarding as a means of obtaining some of these!) and an astonishing variety of small, very sharp knives such as stencil or frisquet cutters, print trimmers and those used in modelling balsa wood. In my first experiments I used a broken piece of a single-edged razor blade, although I do not recommend it as an ideal instrument. Your own ingenuity, plus what works best for you personally, plays an important part. I know of one expert exponent of commercial scraperboard/scratchboard illustrations who uses an ordinary dart to the exclusion of anything else!

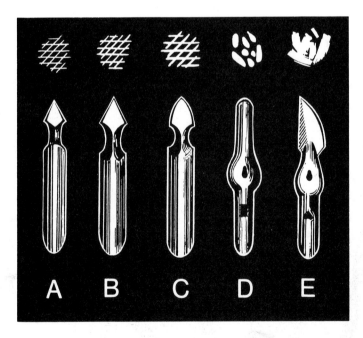

11 Scrapercutters from Scraperboard, Dryad leaflet 507 by Anthony Thacker (Dryad Press). These are the type of tool especially made for the purpose and supplied with craft kits

A steel engraving tool called a scriber is ideal for creating straight parallel lines with a metal rule or, preferably, a carpenter's metal set-square, as well as in free-hand work. There is also a selection of lithographic points of varying thicknesses which consist of square steel rods encased in wood, rather like lead in a pencil, and should be sharpened so that the

tip is diamond-shaped. Sometimes they are already prepared in this form; if not, it can easily be done on a carborundum or oil stone, which is a necessary accessory with all cutting tools in order to retain clean, sharp edges. After placing a drop of oil, preferably mineral oil, on the stone, the lithographic point should be held firmly at a 45° angle, moving it steadily back and forth on the stone until a good point is produced. These are useful not only for straight lines but also where a subject requires mechanically-perfect curved parallel lines. Here you will find a set of French curves are invaluable, but care must be taken not to cut into the French curves themselves and thus render them useless. A pair of dividers or the pointed half of an ordinary pair of compasses are also suitable for this purpose.

Multiple tools

Having taken up the medium after I left art school, I had to discover the best methods for myself. Early on in my progression it occurred to me that the multiple tool employed by wood engravers should also work on scraperboard/scratchboard and might be a way to achieve some exciting effects. My first problem was to find out where one could buy such an article, as it was not available in the large New York art shops with which I was familiar. At last I heard of a small establishment at the foot of the Brooklyn Bridge. With some misgiving, I climbed the dark, rickety

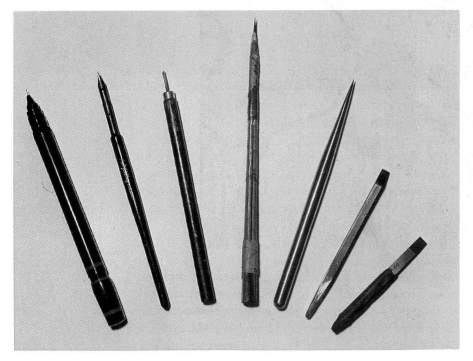

12 Some of my own tools from left to right: Rotring technical pen, crow quill pen, stencil cutter, knife with sharp-angled blade in bamboo holder, German steel engraving tool, multiple tools—a No. 44 with seven lines and a No. 50 with ten (photo: Cyril Littlewood)

stairway to a dimly-lit, dingy workroom cum office. After explaining my requirements to a sympathetic elderly gentleman with a strong German accent, I was shown a promising array of tools like fine hand-chisels about 5 mm ($\frac{1}{4}$ in) wide, set in wooden handles with minute grooves of varying density ending in a serrated edge. This was E.C. Muller's, one of the few specialized suppliers to the needs of wood engravers, and here was just what I wanted. As I was not certain that these would really work satisfactorily on scraperboard/scratchboard, I finally selected just one: a number 50 with twelve cutting points which I still use to this day. Since then, I have had others especially made for me in stainless steel but I always go back to this first one, now removed from its rather cumbersome handle and set in a smaller, light-weight substitute made of plastic wood. As very little pressure is needed on scraperboard/scratchboard as compared with a wooden block, it allows a more delicate touch.

Multiple or lining tools, gravers, or multiple cutters as they are sometimes called, come in different degrees of fineness of line. These are numbered according to the lines per inch (25 mm) based on the rulings of a half-tone screen, and are normally available in four, five or ten lines, though some manufacturers offer a selection of from two to fourteen serrations. The most advantageous use of these, accompanied by demonstrations and examples, will be dealt with in following chapters. It is wise to remember that one can have too many tools. Your technique will progress far better with carefully chosen 'tried and true' favourites (12).

Special pens

An important item on your list should be a limited selection of technical pens which are made for use with waterproof Indian ink. These may seem to be a surprising requisite for a medium that is essentially characterized by white lines on black, which applies equally when working on white scraperboard/scratchboard. However, when using the latter, one can actually have the best of both worlds as they enable one to express even further subtleties of tone, or a variation of mood and atmosphere, by combining a pen and ink technique with that associated with engraving. Fine white lines on both surfaces, sparsely distributed in areas of almost complete darkness, can be broken up by applying a pen to these afterwards if further darkening is necessary.

You will not need a complete set of pen nibs, which range in line thickness from 0.10 mm to 2.0. An 0.20 or 0.25 for the finest lines plus an 0.40 or 0.50 should be adequate. I have used finer ones but they tend to pick up the clay surface material which can clog them very easily. *Faber-Castell* and *Rotring* are two makes that offer a full range of these which fit into either a plastic ready-filled cartridge or an ink reservoir which must be filled from a specifically designed bottle. The two units screw into a

pen holder, but at times I prefer not to use one as I find I have better control for very finely detailed work without it. However, this does not apply when making black lines with the aid of a ruler or French curves. A word of caution – each nib should be rinsed under a cold water tap after using, as drying ink can clog them all too quickly. Afterwards it is important to extract any traces of water remaining inside by wrapping it in several layers of soft tissue and shaking it vigorously and repeatedly, otherwise your inked lines will be diluted and therefore too pale.

Although there are other makes of drawing pens on the market, these two are the best known and can be found on both sides of the Atlantic. *Rotring* (also known under the name of *koh-i-noor* in the States) do two versions: the *Rapidograph* which uses only cartridges, available in five colours as well as black, and the *Isograph* which has a refillable ink tank and is therefore most economical. This company also produces an excellent range of accessories. The *Faber-Castell TG1* can be used with either cartridge or reservoir and has ingenious devices in the cap to prevent ink drying in the drawing point. Damaging of this delicate unit and soiling of the hands is avoided with the aid of their 'cone extractor' when removing it for cleaning or when changing to a different drawing cone.

Another word of warning: only pens which utilize waterproof Indian ink are suitable.

Other equipment

When using white board you will, of course, need black waterproof drawing ink and good watercolour brushes of nylon or red sable in various sizes for applying it. The smaller ones can be used in much the same manner as a pen and also for filling in very limited areas of shadow, thus avoiding unnecessary scraping out.

As will be demonstrated in the step-by-step sections, other requirements are: tracing paper, white or red chalk, or, better still, a white 'pastel' pencil. An alternative to either of these is the curiously named 'dress-maker's tracing paper', produced in packets of five sheets, 20 cm × 45 cm (8 in × 18 in), in an assortment of bright colours together with white. The latter is especially suitable for transferring the lines traced from your 'working' drawing onto black areas as well as the completely black board. The coloured ones can be used as a guide to indicate black outlines on white in place of ordinary black carbon paper, though the only disadvantage is that unwanted or incorrectly-drawn lines are not so easily removed as the chalk or pencil. The product is indeed similar in its application to carbon, rather than tracing paper.

Additional items are plastic erasers and the putty or 'kneader' type which is less inclined to leave an obvious shine on the surface of the board. A soft clothes brush to remove the dust from the ink which is

a *b*

13a One of the designs available in Copperfoil *(Oasis Art & Craft Products)*

13b *Flower design available in* Colourfoil *(Oasis Art & Craft Products)*

scraped off will keep the work cleaner and enable you to see that all lines are sufficiently well-defined. Some artists find that a magnifying glass, particularly one with a supporting stand, is also very helpful for this purpose.

The craft kits

Whilst this is not an article you would expect to see on a list of recommended equipment for the scraperboard/scratchboard enthusiast, the comparatively recent innovation of these 'leisure activity' kits has led to a growing popularity of the medium.

14a *Trying out varying widths of lines on the practice sheet using a scrapercutter*

14b *A pre-printed design for* Colourfoil *in grey guidelines*

a *b*

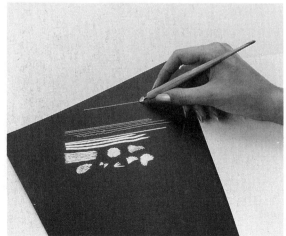
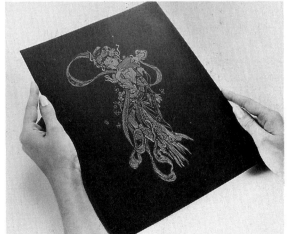

One may chose from four different versions, all with an ever-increasing range of pre-printed designs of varying complexity (*13a & b*). The *Guidelines Scratchboard* is scraped out along faint grey guide lines with the cutter provided to form a white line engraving on black board. *Scraperfoil* has a layer of silver-coloured foil on the under surface, or it can be an aluminium laminated board which is given a matt black coating. When the design is scraped, it reveals metallic areas instead of white. *Copperfoil* or *Coppercraft* has real copper laminated to the board before being coated with black, on which the finished design can be very effective, giving the impression of a copper engraving. The most elaborate of the four is *Colourfoil* (*14a,b,c & d*). The foil used is absorbent which allows the silverfoil design, when completed, to be painted in brilliant colours with combinations of three specially prepared translucent paints. The result is indeed very striking as can be seen in colour plate 7.

Both the silver and copper foil boards are also available in plain packs without designs, each containing three sheets. The silver ones measure 305 mm × 229 mm (12 in × 9 in) and the copper size is 254 mm × 203 mm (10 in × 8 in). The smaller black boards for beginners which scrape out to white have already been mentioned in the first part of this chapter. These can act as a spur to the more adventurous would-be artists to create their own compositions in this exciting new medium. Having tried the pre-printed designs and experimented on the practice sheet provided with each kit, the artistically-inclined amateur is often inspired by the effects which can be obtained, just as in a similar way many have had the courage to take up oil painting after using painting-by-numbers kits.

14c Scraping out to the silverfoil surface underneath with a protective piece of paper under the hand

14d Painting in the colours on the scraped out design with special translucent paints (*Oasis Arts & Craft Products*)

c

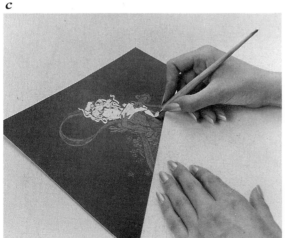

d

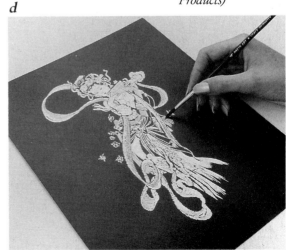

3 TECHNICAL APPLICATION

I have entitled this book 'The Art of Scraperboard *Engraving*' because it is basically a type of engraving, albeit a more delicate method than earlier forms, though one also scrapes or scratches the inked surface—hence the terms 'scraper' or, as in the United States, 'scratch' board apply equally well. The challenge presented by engraving is that one has only pure black and white with which to present three-dimensional objects on a flat surface as well as tones of infinite subtlety to create the illusion of distance. One might say that part of its charm lies in its limitation.

Having obtained the equipment you will need, it is best to try out the tools first on a spare piece of black board to familiarize yourself with the effects that can be produced as well as the manner of holding them which suits you best. Freehand curves, straight and broken lines, cross-hatching and dots or dashes, increasing in thickness or density, all express tonal values. Next, one can experiment in the same way with white board, not only with small areas that have been painted black, but also working on lines or dots applied with a fine brush or pen by cutting into them to achieve endless permutations (*15a & b*). Their application in conveying textures will, with practice, become obvious.

15a Half-tone effects on black and white boards. ESSDEE Scraperboards/ scratchboards (British Process Boards)

15b Half-tone effects on black using a No. 50 multiple tool

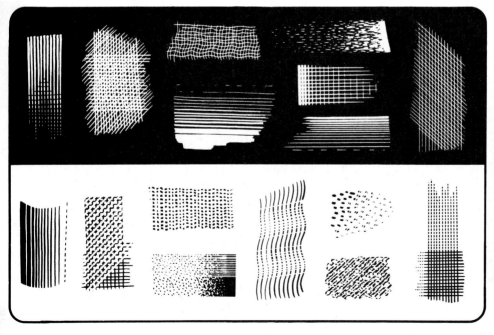

The importance of light

As with any other medium, there is no substitute for craftsmanship and a grasp of composition plus the ability to interpret form and the effect of light upon it. The latter plays a particularly important part in the successful rendering of any study in scraperboard/scratchboard. In fact, the direction from which it emanates, especially on black board (16) is a paramount ingredient. Reflected light, whether actually seen or imagined, realistically depicted or slightly exaggerated, can often add greatly to an impression of solidity. Working from either the actual subject or a photograph, one frequently has to look for it. A great American painter expressed a wish that, in the life hereafter, he would be able to paint with light. Perhaps the best practitioners of engraving media would aspire to draw with it.

16 Illustration on black board, 297 mm × 197 mm (11¾ in × 7¾ in) for African Valley by R.H. Ferry (Frederick Muller). The lighting from below creates a nocturnal atmosphere. The blurred scene of the elephants above represents the old man's thoughts from the past

Textures

Of course, the most appropriate technique is, in many instances, dictated by the subject matter itself, such as the texture of fur, its length and direction of growth, as can be seen in the study of the squirrel (17). In the original, the animal is life-sized to allow maximum opportunity for detail; when it was subsequently reproduced on a greetings card, where it was reduced to a third of the original, none of this was lost. The entire figure of the squirrel, except for the white areas around the mouth and neck, was painted black, as were the shadowed parts of the branch and

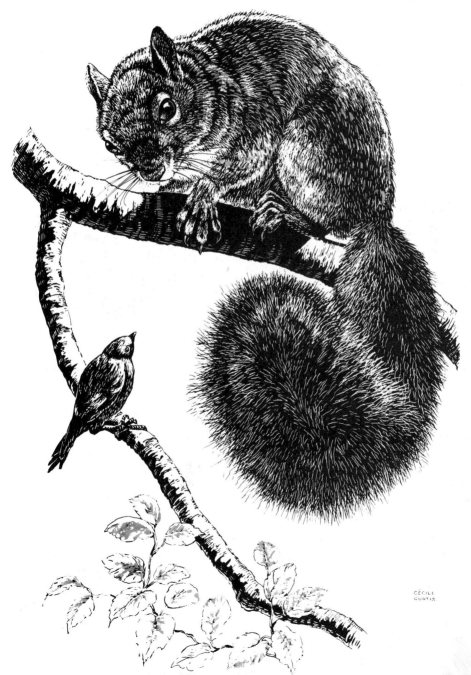

17 *Study of a squirrel on white board used for a greetings card, 350 mm × 245 mm (14 in × 9¾ in) is an ideal subject for the medium (F.J. Warren, art publisher)*

leaves, thus heightening the effect of strong sunlight on these areas and at the same time providing the use of an entirely different technique. The texture of the bark is also distinct from the leaves, on which only the multiple tool was employed to lighten the shaded parts. The bird, seen here as grey, was originally red to match the wide border on the card. Although there is some suggestion of reflected light on the squirrel's cheek, leg and haunch, in reality the creature is paler on its underparts, as are many animals, to afford protective coloration—the fur on top being darker where light is most intense than the areas in shadow in order to present a flatter, less conspicuous image to a potential predator. An impression of roundness is conveyed here by accentuating highlights on its back and the edge of its tail.

The smaller pictures illustrate varied renderings of textures. In order to express those of the diverse assortment of vegetables (18), contrast was achieved by painting some entirely black and leaving others mostly white. Here the multiple tool was very useful, particularly on those with smooth, shiny skins.

18 Illustration for Chester County Cookery (Princeton University Press). A typical display of the wide variety of American squashes, pumpkins and other vegetables

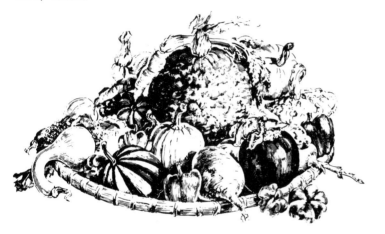

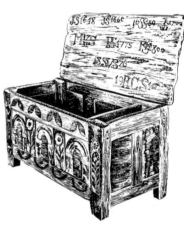

Different graining and rough, inlaid-wood designs on the antique 'hope chest' (19) and the ornate chair (20) required the filling in of some sections with solid black which were then cut with both bold and delicate lines and dashes, giving contrast to the pen and ink technique of others.

Metal provides wonderful scope for the scraperboard/scratchboard artist with its great complexity of highlights and reflections. Old silver (21, 22 & 23), pewter (24) copper (25) and brass (26 & 27) objects lend themselves to interpretation in the form of line engravings. These examples were all cut from black silhouettes, except for the last illustration where the light area of the globe was left white.

An unusual opportunity presented itself when illustrating my children's story set in London Zoo. I had decided on a close-up portrait of one of a pair of white rhino which were normally in a paddock, usually some distance from the visitors, or, worse still, inside their indoor quarters

19 'Hope Chest', a modest heirloom passed down through several generations of American brides-to-be in which to store their linens and other household items for their future married life. The carvings show a 'Pennsylvania Dutch' influence (Newcomen Society publication)

*20 Ornately carved
wooden chair
(Newcomen Society
publication)*

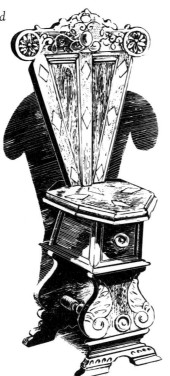

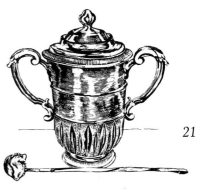

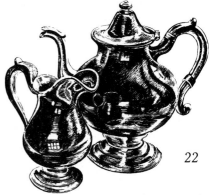

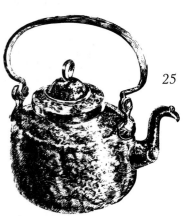

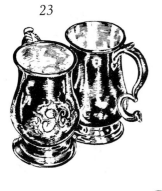

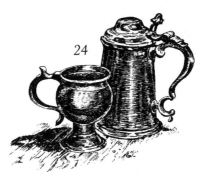

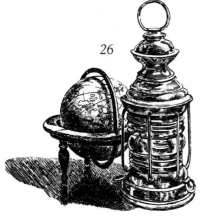

*21, 22 and
23 Old silver,
pewter (24), copper
(25) and brass (26
and 27) objects are
all very well suited
to this line technique
(Newcomen Society
publications)*

hidden completely from view. This is not an uncommon problem when drawing zoo animals from life. As work was in progress on new housing for them, the male was temporarily confined to a small building during the day where, the keeper assured me, it would be quite safe for me to work on my detailed drawing of him. I was, understandably, a bit anxious about this arrangement; nevertheless, armed with sketchbook and a very

28 White rhino and mouse. Illustration for my book, Woody's Wonderful World (Hodder & Stoughton and F.J. Warren, art publisher), 350 mm × 300 mm (14 in × 12 in), one of series of fine arts prints (both with and without the mouse) in its original size

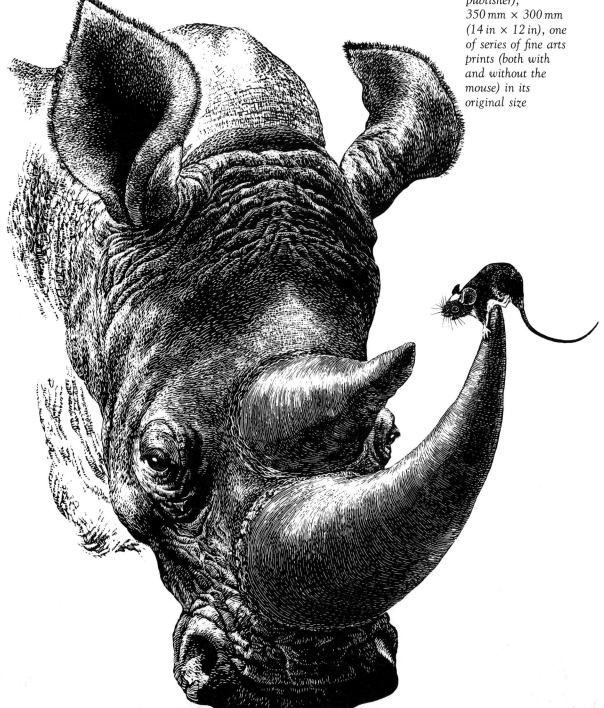

large bag of carrots to keep my model attentive, I entered, somewhat hesitantly. To my great satisfaction, I found that I could get close enough actually to touch him and feel the strange, rough texture of his skin, while concrete bollards at one end of the room allowed me to get his head and neck through them to reach my 'bribes' but prevented me being crushed by the enormous bulk of 4000 kilos (8800 lb) at the other end. An exhaustive study of photographs, or observation of the animal outside the fence of an enclosure, could not have revealed the wonderful detail of delicately fur-fringed ears and thick, stubby eyelashes (28) that this close proximity permitted. An hour or so and several carrots later, I came away with a pencilled impression which, having been subsequently enlarged to the size I wished to work on, enabled me to start on the final stages of this impressive subject so suitable for the medium. After tracing and transferring it to the board, I painted the head entirely in black right up to just behind the ears. The beginning of the neck was only partially blacked in around the outline of the hump and in the deep folds to fade this portion out and at the same time make the rest appear to come toward the viewer.

White scraperboard/scratchboard was the obvious choice in this example, giving dramatic impact to the forward thrust of head and horns on which careful, free-hand engraving of lines to express shape and perspective played a major part in achieving the feeling of three dimensions.

As a mouse featured in most of my illustrations for this story, I had acquired one at a local pet shop which I was able to sketch in different positions whilst he played in his cage equipped with a wheel and a small ladder, which was particularly helpful. Perched on the top rung, he assumed just the right pose to balance on a rhino's horn. In the original version, the mouse is brown and the illustration was reproduced in the two colours in the book.

This study, together with others from my own books, was destined to become one of a series of fine arts prints in its full size both with and without the addition of the little character. It also appeared, reduced by slightly over one half, on greetings cards and calendar prints in a process called *Dufex* to which scraperboard/scratchboard is admirably suited. One of these cards can be seen on the jacket front. This unique method involves printing a design on gold or silver-coloured aluminium laminate, the surface of which is then faintly textured or 'debossed' so that some of the original white areas catch more light than others. By moving the picture even fractionally, these change, giving animation to the image with a quite startling effect.

The textures of sculpted or carved figures are also ideal for expressing in line techniques. Although the play of light and shade on form is naturally a predominant feature, the material from which it was made can be most adequately conveyed in the medium of scraperboard/scratchboard.

The imposing marble statue of Abraham Lincoln (29) in the Washington

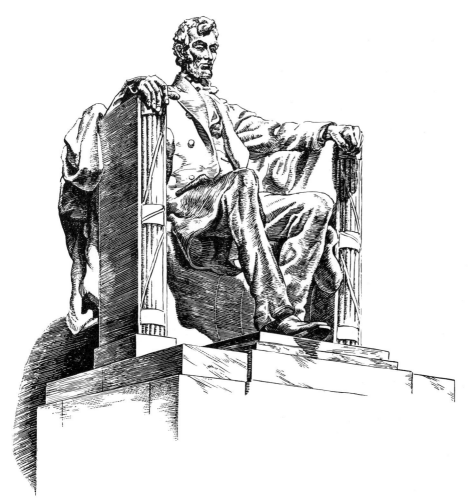

memorial that bears his name was an outstanding subject. I was able to
visit the site at different times of day before deciding on the hour when
the sun struck it at the most advantageous angle. By happy coincidence,
the light on the edge of the drapery on the left cast an interesting reflection
in the smooth side of the bench. Except for a few penned lines on this
and the pedestal, all the shading was cut from black leaving the large,
sunlit areas white.

In contrast, the time-worn stone of the medieval figure in Bremen (*30*)
with its rough pitted surface, was best conveyed with coarse dots and
small areas of pure black which were then lightened with the multiple
tool.

The Etruscan bronze (*31*) of the fifth century BC was started as a black
silhouette except for the light on the plinth. Highlights were cut out boldly
to emulate the shiny surface of metal.

A variation in the treatment of shading on the figure carved in wood

30 *Town Hall in Bremen, illustration for* Look at Germany *by Eleanor Brockett (Hamish Hamilton)*

31 *Etruscan bronze, illustration for* Look at Italy *by James Welland (Hamish Hamilton)*

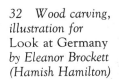

32 *Wood carving, illustration for* Look at Germany *by Eleanor Brockett (Hamish Hamilton)*

and that of the man (*32*), together with a carefully chosen direction of light, helps to separate the two.

The last three examples were done for books with a small page size of 120 mm × 185 mm (4¾ in × 7¼ in), and the original illustrations were only half again larger than the reproductions. This did not permit great subtlety of treatment as very fine lines would have been lost on rough, uncoated paper, so a more positive 'open' technique was necessary.

Black or white board?

Many subjects can be equally well interpreted on either, but the deciding factor when the choice is not an obvious one is often the purpose for which the artwork is to be used, rather than purely aesthetic considerations. For instance, it is frequently desirable to represent it in a vignette form, especially in conjunction with typeface as in book illustration, when white board is preferable to avoid scraping a great amount of black area from the corners.

The two illustrations of a lion's head show totally different approaches to the same subject. The first (*33*) on black board was engraved exclusively

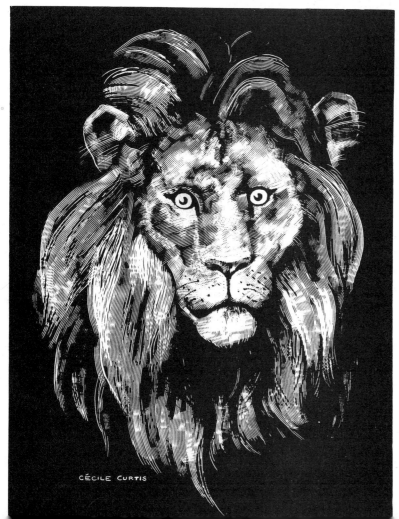

33 Lion, Pharaoh, on black board, illustration for Bears, Owls, Tigers and Others! *by Williams Biddle Cadwalader (The Newcomen Society in the United States) 192 mm × 140 mm (7½ in × 5½ in)*

with the multiple tool, except for the eyes which I scraped out to white in order to emphasize the intensity of the expression. I had initially noted this in a rapid sketch of the animal in the Philadelphia Zoo at the moment when he had just caught sight of his keeper delivering the daily meal. The lightest areas of the face and mane were made with repeated strokes of the tool using a lot of pressure. A slight suggestion of whiskers was added with a pen afterwards, as were the few dark hairs of the mane under the chin.

34 Lion on white board, another illustration for He Looks This Way *(Frederick Warne and F.J. Warren, art publisher) 240 mm × 215 mm (9¾ in × 8¼ in), one of the series of fine arts prints, calendars, cards, etc.*

The larger study on white (34) appears at first glance to be mainly brush and pen work but is enhanced by the addition of a different tone or 'colour' in the areas on the upper lip, cheek, eye and ear. This was achieved by cutting into solid black. The whiskers were cut across the black pen and brush lines. Although initially intended only as an illustration for one of my books, like the rhino this also became a fine arts print in its original size as well as a greetings card in the gold Dufex process, and was also reduced to a mere 48 mm (2 in) high on gift enclosure cards. Later it appeared together with others of my designs on postcards in 'silver' Dufex as well as black on white. These are now available in several countries including many of those where the animals originated.

The picture of a doorway and the room and window beyond it (35)

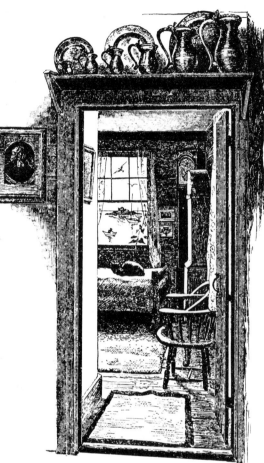

35 *Interior of Sir William's counting house, illustration for* Sir William Pepperrell, Bart., (1696–1759) *by Joseph W.P. Frost (The Newcomen Society in the United States)*

36 *Exterior of counting house from the same book, 295 mm × 200 mm (11½ in × 8 in)*

could probably have been just as effective on black as on white board. I chose the latter as it would accompany typeface in a book and a vignette seemed the most suitable. It also eliminated the necessity for a great deal of black around the door, the source of light being from the window. The pewter objects on the shelf above could be featured in a more positive way, the framed picture on the left breaking up the straight vertical line which would not have been such a focal point on black board. Most of the engraving was done out of solid blocks using mainly the multiple tool, cross-hatching the reflected light on the ceiling. The large white areas were shaded with a pen giving a nice contrast in technique.

The next example on white board (36) shows the exterior of the same house where the multiple tool was employed only on the background of trees to suggest distance.

In this interior of an American colonial kitchen (37) the room was dark and narrow and demanded the employment of black board. Sunlight through the top of the small window was the only source of light. Everything surrounding it was illuminated by reflected light from the patch of sunlight on the right which is, of course, accentuated here to bring out the rough textures of floor, walls and fireplace in which the

37 *American colonial kitchen in Portsmouth, New Hampshire, illustration on black board for* Chester County Cookery *(Princeton University Press) and* Electric Power and History in Southeastern New Hampshire *by R.C.L. Greer (The Newcomen Society in the United States) 279 mm × 228 mm (11 in × 9 in)*

bricks, hearth and wood were defined with short strokes of the multiple tool. By cutting alternately vertically and horizontally it created a much-needed difference in these surfaces, separating this area from the adjacent walls.

A predominantly white animal does not necessarily have to be depicted on black, but in the case of this study for a book jacket (38) it seemed preferable, giving much more impact to the dog's head. The picture was enclosed within a narrow gold border and the surrounding area printed in bright red with black lettering creating a striking 'frame' for the engraving. The markings on the dog's face and ear had to be clearly distinguished from the white areas of the coat but still be light enough to stand out from the background. Bearing this in mind, I chose the most appropriate one from several individuals in the pack and was very gratified when, on seeing the finished work, the owner instantly recognized it.

The dark seclusion of a lion's den is certainly enhanced by the use of black board in this book illustration (39) which was printed on a full page.

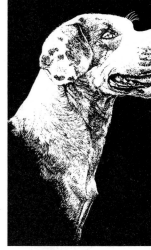

38 Illustration on black board, part of the jacket for The Book of the Foxhound *by Daphne Moore (J.A. Allen)*

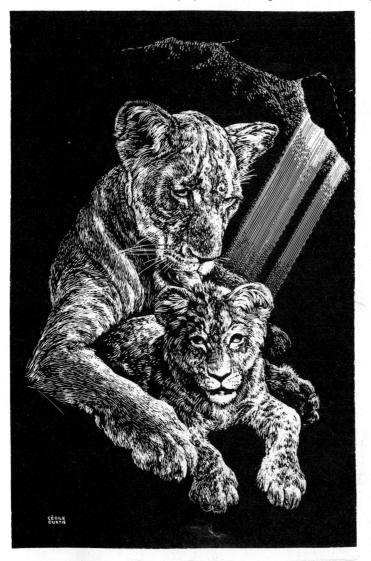

39 Lioness and cub, illustration on black board for African Valley *by R.H. Ferry (Frederick Muller) 297 mm × 197 mm (11¾ in × 7¾ in)*

The solid, enclosing black gives a sense of intimacy, and the shaft of light, made without much pressure using a scriber and ruler, provides a point of illumination to highlight the tongue of the lioness and her cub's back. The emphasis of top and reflected light on her paws helps to express its form. As lion cubs have faint spots when very young to serve as much needed protective coloration, it gave me the opportunity to suggest a slight difference in their colouring. I had previously observed this characteristic at first hand at London Zoo when handed a wriggling, orphaned youngster to hold.

The ominous mood of a seedy, gas-lit side street in Victorian London was obviously an appropriate subject to depict on black (40). As all my other illustrations in this book were done in pen and ink, it offered the opportunity not only for a variation in technique, but also for a total contrast in atmosphere.

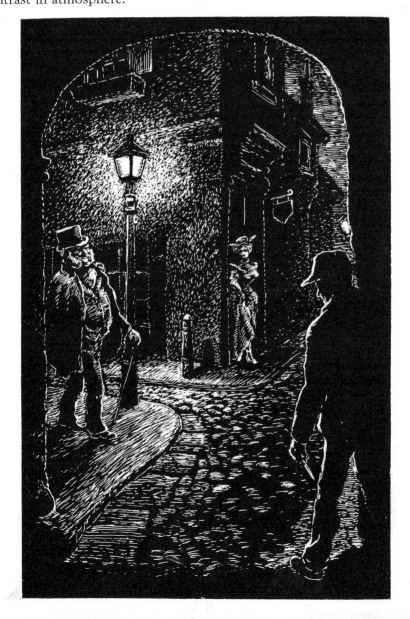

40 The haunt of Jack the Ripper, *illustration on black board for* East End Passport *by Roy Curtis (Macdonald)* 190 mm × 125 mm (7½ in × 5 in)

Grained and stippled boards

These give one a great variety of choice. Besides the selection of screened surfaces, whether to choose black or white versions is sometimes a difficult decision. These skilful renderings of metal work by A. Webster would both appear to have been done on white, but the ornate door knocker (41) is an excellent example on a coarse, irregular grained black board, the background wood being almost entirely scraped out, whereas the iron grillwork (42) is on a cross-embossed white screened board.

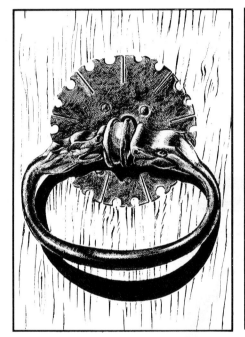

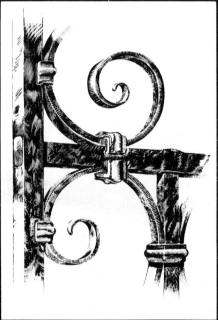

41 A Webster, illustration on grained black board for Scraperboard *Dryad leaflet 507 by Anthony Thacker (Dryad Press)*

42 A. Webster, detail of iron railing on cross-embossed white screened board. Illustration for Scraperboard *Dryad leaflet 507 by Anthony Thacker (Dryad Press)*

C.F. Tunnicliffe's charming study of eiders on rocks (43) produces a convincing effect of half-tone technique on screened board and could have been done on either the black or white variety.

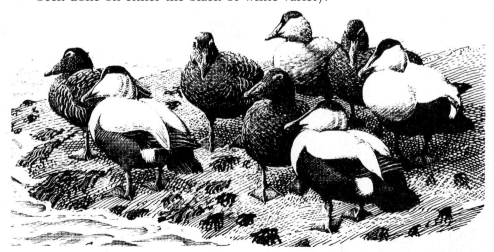

43 Charles Tunnicliffe (1901–79), Eiders on Rocks, textured screened board, from Diary of a Country Artist *by Ian Niall (Victor Gollancz) (Courtesy of the Trustees of the Estate of Charles Tunnicliffe)*

I have used both for designs specifically created for Christmas cards reproduced in the aforementioned Dufex process. The composition 'A King is Born' (44) was one of these and in this instance I chose the finely stippled 15A board with a sand grain, the black version of which is shown in illustration 10. Unlike the other mechanical-looking patterns, this and the 22A give a pleasant, slightly uneven distribution of dots, the former, when scraped, showing white on black and the latter the reverse. These embossed boards in either black or white can be scraped to reveal the pattern to a greater or lesser degree or engraved in the same technique as smooth board. Black can be applied to the white version with Chinagraph pencil as well as ink, thus increasing the scope of effects obtainable.

44 *Design on stippled white board for Christmas card, A King is Born (F.J. Warren, art publisher) 279 mm × 165 mm (11 in × 6½ in)*

With the gold foil process in mind, I left the three kings predominately white with mostly soft shading made possible by the stippled surface. This helped these figures to stand out against the dark shadow on the wall where short dashes rather than dots create another texture and contrast with black dots applied with a pen to its lighted area. The robe of the Madonna was sparingly cut from solid black to bring it to the foreground using the same principal as employed in the head of the rhino.

Portraiture

Faces with character are especially relevant to this medium and the more lines and wrinkles, the greater the opportunity to convey it. A typical example is the study of that great story-teller Somerset Maugham (45). The sad wisdom which his hooded eyes epitomize could be so well defined by the delicacy of engraved lines on black board.

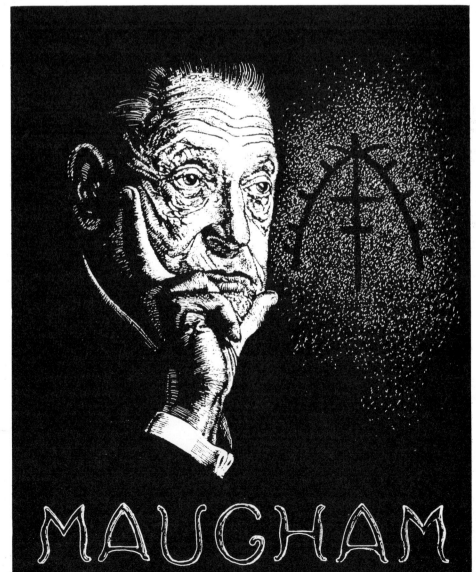

45 Somerset Maugham portrait on black board with his 'trademark'

I was principally guided by one photograph but referred to others as well to obtain greater insight to the subtleties of the personality, often a useful practice when not working from life.

In the background I used his trademark, a Moorish symbol of the hand of Fatima in a highly-stylized version, which appeared on the jackets or title pages of his books and was etched in red on the white plaster at the entrance to Villa Mauresque, his home on the Riviera. This is faintly discernible in a stippled treatment fading out to pure black as does the shadowed area of the figure itself.

In much the same way, the lined face of the old Spanish *paisana* shown in colour plate 3, offered an equally suitable opportunity when depicting this weathered but serene countenance against the rough bark of an *algarroba* tree. Her work-worn hands were folded in unaccustomed repose as she sat patiently whilst I sketched her, no doubt somewhat bemused that I should consider her a subject worth my time.

With the uncompromising, arid landscape of Andalucia as a backdrop, the head of the Spanish farmer in colour plate 2 is very much in keeping with this rugged terrain. It was with some difficulty that I dissuaded him from having his weekly shave before sitting for me. Even with my fairly fluent Spanish, it would have been impossible to explain to him that the textural advantage of several days growth of beard was an essential attribute!

Dignity and strength are the predominant qualities in the figure of the snowy-haired African (46). This technique on white board contrasts with the treatment of a similar subject in the earlier example (16) on black. The windblown portion of the robe was a device to set off his crisp, white hair shaded mainly with a pen, against the shadow of the cloth cut with a multiple tool, its outlines being merely dots made with a pen. In this way, the highlights and middle tones of the black skin stand out as a separate entity.

A child is a far more difficult subject for a scraperboard/scratchboard portrait. The soft contours of young faces demand a great deal of restraint, with shading kept to an absolute minimum. Only the facility of using white lines on black, as in the rendering of hair, as well as the reverse, gives more scope than a pen and ink drawing. The five children in the double-spread illustration (47) demonstrate a combination of the two.

In the small close-up of a little girl (48) her hair as well as her face are pen and brush technique with only a slight amount of scraping out. Besides a softer effect, there is a distinctly different texture in the more precise and detailed approach to the bumble bee and flowers, whose leaves and buds were washed over with green ink, making these items appear closer while the indispensable multiple tool gives them form.

The young African boy in colour plate 4 with a starlit sky behind him did not present so many problems in shading. Here a more positive

technique was possible in the cutting of the light areas on the face. The general effect is somehow softened by the dark colour behind it against which the highlights stand out.

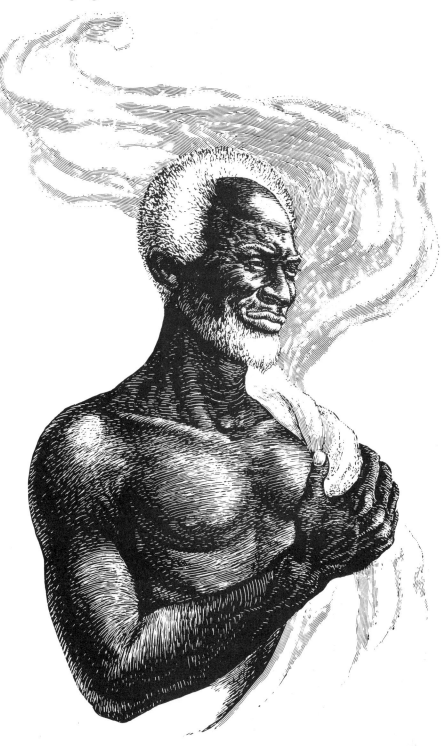

46 *This illustration for* He Looks This Way *(Frederick Warne)* *255 mm × 165 mm (10 in × 6½ in) clearly shows the advantages of the multiple tool*

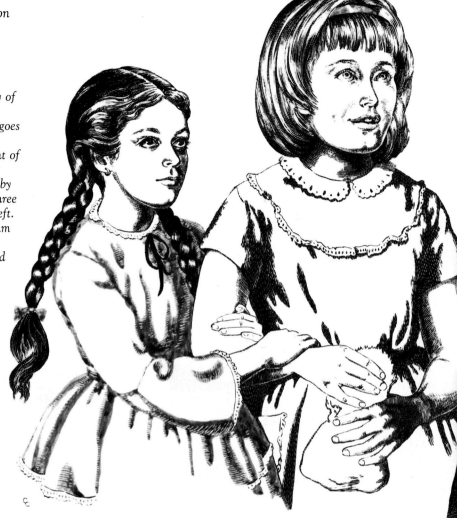

47 In this study of five children, the elephant's trunk goes up out of the picture, the height of the animal being merely suggested by the gaze of the three children on the left. 363 mm × 580 mm (14 in × 23 in), done in black and red

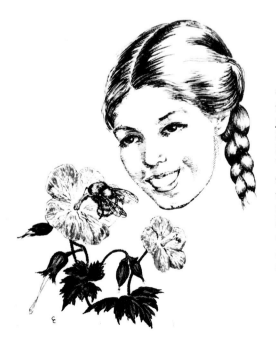

48 One of the many illustrations for my book, Samantha and the Swan *(Frederick Warne),* for which my daughter was the model. The grey tone on leaves and buds was printed in viridian green. 220 mm × 183 mm ($8\frac{1}{2}$ in × $7\frac{1}{4}$ in)

Buildings and landscape

These subjects, on their own or in combination, featured in the major part of my earlier work on scraperboard/scratchboard. With a profusion of places of historical interest as well as picturesque rural scenes and even recently-built houses to portray, I soon came to appreciate the advantages of scraperboard/scratchboard in conveying different materials by the interchange of black lines on white with the reverse.

The addition of a tree or the suggestion of a landscape often contributes greatly to a composition and creates a sense of proportion, at the same time providing the means of utilizing different techniques. The vignette is a most effective form of illustration in this category, but the decision as to what to leave out and where is one which has to be carefully considered. The early American clapboard house with its protruding upper storey is a case in point (49). The remnants of fencing in the foreground give atmosphere and perspective to the composition with an uncluttered simplicity which emphasizes the starkness of the isolated dwelling.

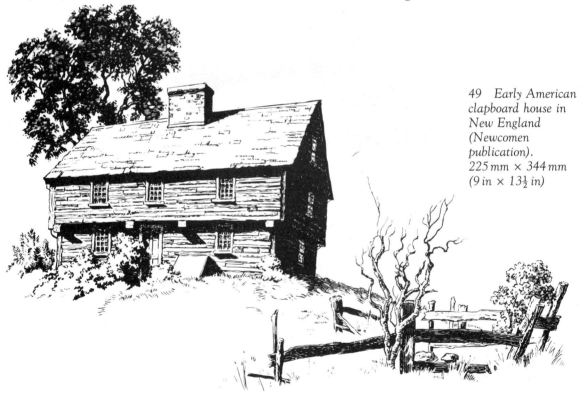

49 *Early American clapboard house in New England (Newcomen publication). 225 mm × 344 mm (9 in × 13½ in)*

The indication of sky fills an essential need in this scene of a village hostelry in Devon (50), with its shops and church tower beyond, by helping to define the upper limits of white and pale stone structures. Here the difference in tone was achieved with long, slanting strokes of the multiple tool. The outermost parts are contained by the tree on the left

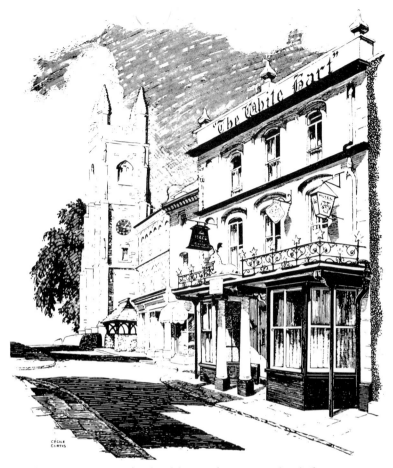

and just the suggestion of a building of an entirely different material on the right. The narrowness of the street is conveyed by cast shadows of unseen buildings on the other side.

While this modern house has undoubted charm (*51*), it is due, in part at least, to the encompassing landscape. A deliberate choice of oblique sunlight gives character to its construction despite its newness, by accentuating textures. Where there are many windows to deal with, it is always desirable to find a diversity of representation. Here, the upper ones at the front are distinguished from the rest as they are only defined by reflections of foliage from the surrounding trees which were scraped out from solid black with a multiple tool. Afterwards, touches of black were added on top of this tone on the two nearest to separate them from those at a greater distance, thus introducing another variation in technique.

The overhanging branch of a tree and the shadow beneath it can often be used to advantage to 'frame' what would otherwise be a somewhat uninspired composition. The leaves can be left for the most part in black silhouette with just a slight definition of form in order to place the scene beyond in a more distant plane.

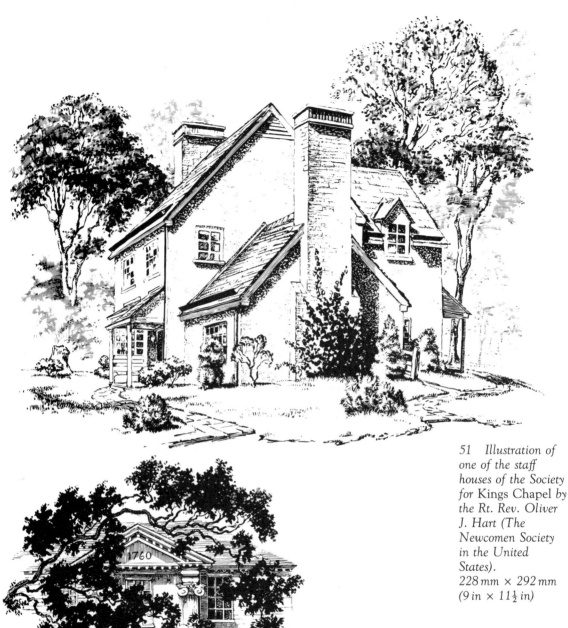

51 *Illustration of
one of the staff
houses of the Society
for Kings Chapel by
the Rt. Rev. Oliver
J. Hart (The
Newcomen Society
in the United
States).
228 mm × 292 mm
(9 in × 11½ in)*

52 *The Lady
Pepperrell House,
illustration for Sir
William Pepperrell,
Bart. by Joseph W.P.
Frost (The Newcomen
Society in the United
States).
220 mm × 195 mm
(9 in × 7½ in)*

The gateway and door of this historic home in Kittery Point, Maine (52), are its most important features and the tree in front helps to focus on these areas by eliminating the distraction of too much fussy detail of windows and the rest of the building.

Yet another problem was presented by this low-lying cottage with dormer windows (53). Nestled amongst a profusion of trees and shrubs, it was impossible to find an angle which would feature any one section in detail. Here again, the framework of foreground foliage and shadow was a happy solution and allowed the road and fence to lead one into the picture, giving it an atmosphere of cosy tranquility.

A far more grandiose urban scene of this spacious museum (54) needed quite a different interpretation. There were no masses of dark trees to set off the building, which had to be presented in a somewhat subdued and simplified style in order to feature the monument in front with its complex grouping of statues and the many steps leading up to it. The solution was to leave the flight of steps beyond almost blank with the merest suggestion of lines. The columns on the right of the portico could be conveniently faded out to nothing, being white against white. The cloud formation,

53 Country cottage in New England, using principle of trees and shadow as a 'frame' (Newcomen pubication). 242 mm × 305 mm (9½ in × 12 in)

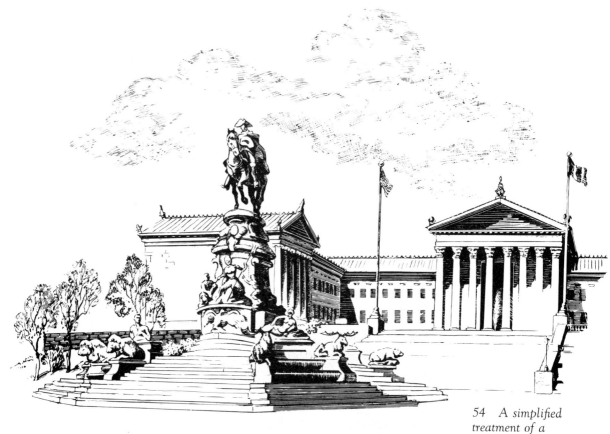

54 *A simplified
treatment of a
complicated subject
(Newcomen
publication).
215 mm × 325 mm
($8\frac{1}{2}$ in × $12\frac{3}{4}$ in)*

55 *Pennsylvania
barn built of
fieldstone. Chapter
heading for* Chester
County Cookery
*(Princeton University
Press)*

whose shading was heavily scraped out, gives a relief to the profusion of horizontal lines and leads the eye back up to the dominating equestrian figure.

Rural scenes of farm buildings are often quite effective without the embellishment of trees and landscape. The small barn with resident guinea fowl (55) certainly possesses sufficient character to stand on its own. The silo and corn crib (56) is another such example. Here the multiple tool made possible a simplified rendering of the shadow on the silo with a little cross-hatching in the area of reflected light. These delicate lines remained intact even when printed in dark brown on the cloth of a book cover as well as its paper jacket, and when reduced even further to less than one half the size of the original in another reproduction.

56 *Jacket design and chapter separator for* Chester County Cookery (*Princeton University Press*). *200 mm × 130 mm (7¾ in × 5 in)*

57 The village of Mojácar in Andalucia, the last place in Spain occupied by the Moors.
190 mm × 242 mm (7½ in × 9½ in).
Part of the same tree can be seen in colour plate 3

58 Covered bridge in Pennsylvania, chapter separator for Chester County Cookery (Princeton University Press). The object of this type of structure is to protect the bridge in winter from heavy snow. The local lads find the 'windows' very useful for fishing!

In these four examples (*57, 58, 59 & 60*) the reverse situation prevails in that the structures in the background are subordinate to the trees and surrounding landscape and typify the advantages for interpretation of both elements in this medium.

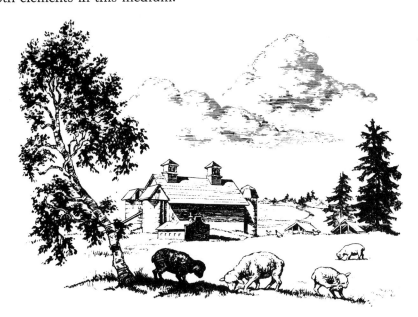

59 Landscape with farm (Newcomen publication) greatly reduced from 210 mm × 285 mm (8¼ in × 11¼ in)

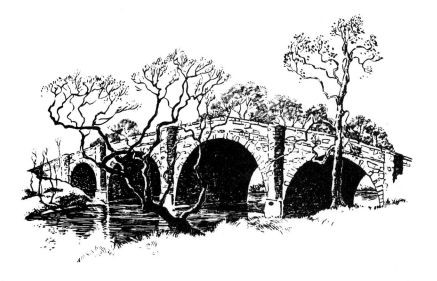

60 Trees with stone bridge (Newcomen publication). 150 mm × 280 mm (6 in × 11 in)

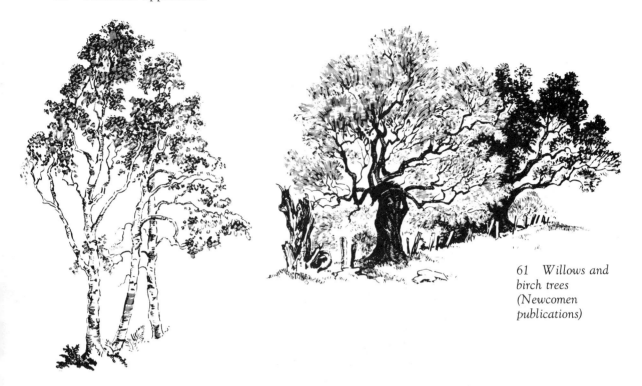

61 *Willows and birch trees (Newcomen publications)*

62 *Stunted pine twisted by strong gales (Newcomen publications)*

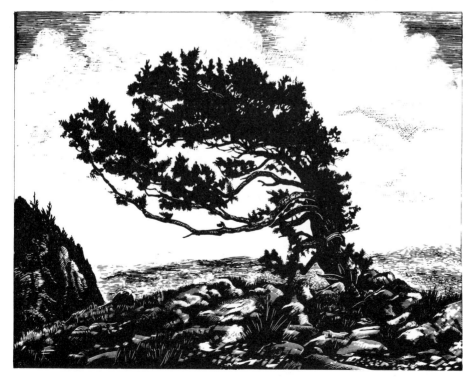

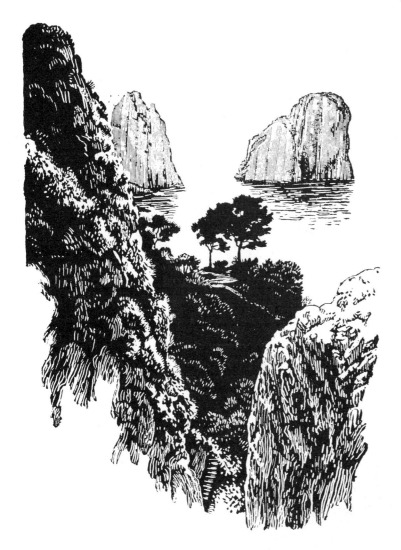

Trees on their own are delightful subjects in any medium. Even without the attraction of colour, scraperboard/scratchboard is still sufficiently versatile to give adequate delineation to the various species (*61 & 62*). The rugged rock formations in this drawing of the bay at Capri (*63*) are also very easily interpreted in black and white engraving.

The interiors of buildings usually involve a complicated combination of different objects and frequently a lack of sufficient lighting to show them to their best advantage. The Church of the Presidents in Washington DC (*64*) was no exception. In order to give greater clarity and definition, some sections, such as the front of the altar, the windows and pews in the foreground, were left white and worked with the pen only, while the light on the right-hand side was somewhat exaggerated to bring out the form of the marble column and flag.

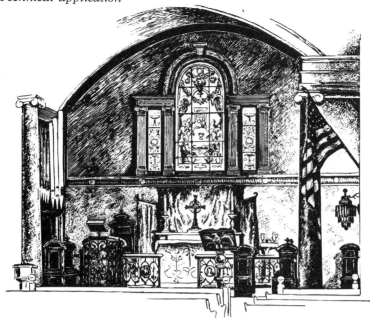

64 *Interior of the 'Church of the Presidents', illustration for* That We May Know! *by Leslie Glenn (the Newcomen Society in the United States)*

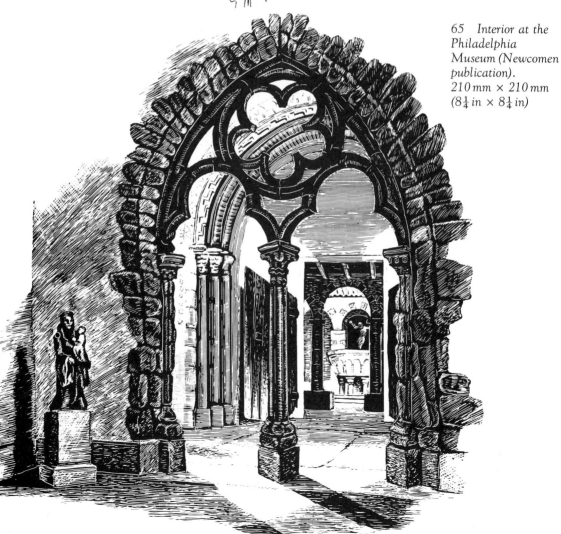

65 *Interior at the Philadelphia Museum (Newcomen publication).*
210 mm × 210 mm
(8¼ in × 8¼ in)

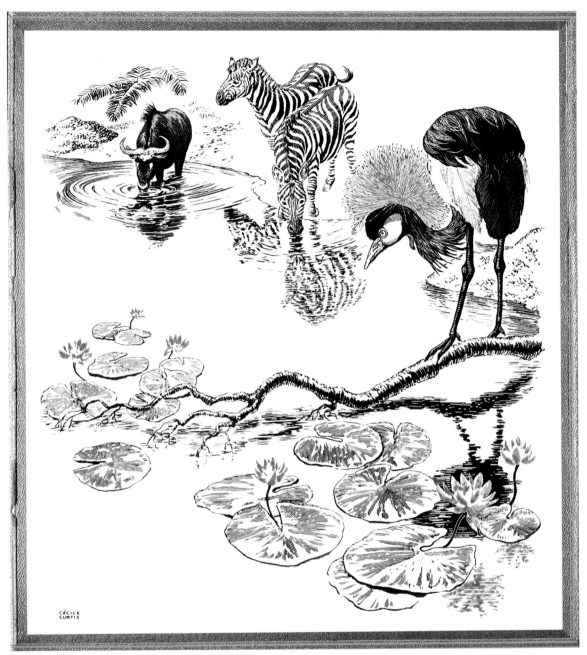

Crowned crane, zebra and wildebeest, illustration for
He Looks This Way (Frederick Warne) 290 mm × 265 mm
(11¼ in × 10½ in)

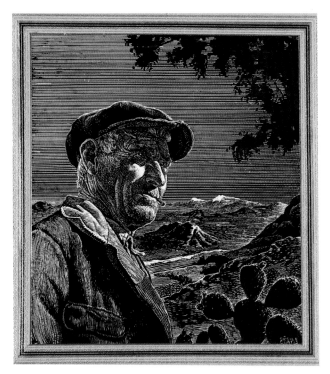

2 Tio Pedro 240 mm × 217 mm (9½ in × 8½ in)

3 Tia Luisa 352 mm × 278 mm (13¾ in × 11 in)

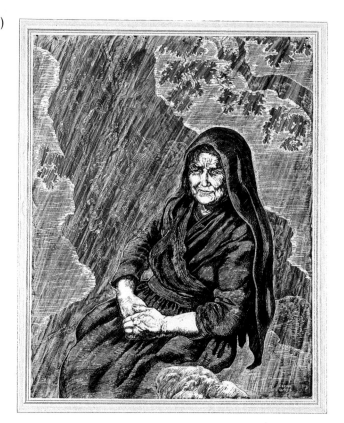

66 *A dining room
in seventeeth-century
America (Newcomen
publication).*
348 mm × 273 mm
(12¾ in × 10¾ in)

The Philadelphia Museum was a fascinating assignment, especially this view of a series of archways (65). The ancient stonework of the nearest of these with its interesting pattern offered an ideal way to finish the right-hand limit of the picture in a decorative manner.

This seventeenth-century dining room (66) was quite another matter. With so many interesting features it was, in this instance, extremely difficult to decide where to stop. The fading of the fireplace near its centre was indeed somewhat awkward, but to have included any more would

have ruined the composition. An alternative would, of course, have been to enclose it completely in a rectangle rather than showing it in the form of a vignette, but this would have necessitated having the left side of the room in virtual darkness, giving too much weight to this area and detracting from the rest.

We have examined the possible treatments of a variety of subjects which may help you to decide which of them interests you the most. Whatever your preferences may be, there are certain procedures that I shall recommend in the following pages in order to smooth the way in your initial experiences with this exciting medium.

4 STEP BY STEP ON BLACK BOARD

I shall demonstrate the procedure on black scraperboard/scratchboard first for the benefit of those who may have had some limited introduction to the medium, either through working with craft kits or when attending art classes where black is usually presented to the beginner. Surprisingly, there are many people who do not know that white scraperboard/scratchboard exists! Black is not necessarily easier, though there are fewer stages in the initial preparation.

For this example, I have chosen to illustrate the opening paragraph in my text which refers to the first evidence of engraving. It seemed an eminently suitable subject for black scraperboard/scratchboard, not only because of its limited source of light, but also for its undeniably fascinating content as well. In the composition, a tallow lamp, for the sake of convenience, is hidden from view since its flame would need to be pure white which could not then be used anywhere else. Within this subterranean studio, different versions of Paleolithic art are included, not derived from any one source, but in an imaginary combination. On the left, an early form of painting depicts a stag's head resembling the present fallow deer and is typical of the Saloutrian period of 18,000 years ago. The Cro-Magnon artist uses a 'parrot-beak' burin of sharp flint to engrave a bull aurochs on the cave wall above the bas-relief of a horse which is strikingly similar to the wild Przewalski's horse still extant in Southern Asia. These last two representations would most likely have been produced during the Magdalenian epoch around 3000 years later, as cave decoration often continued over many centuries in one location. I have shown the man wearing a sort of loin-coth, not to imply modesty on his part, but merely for the very useful line it lends to the composition!

The working drawing

Having decided on the subject, it is essential to do a fairly detailed sketch in which all the elements of composition and lighting can be worked out. It need not be a highly-finished looking work with a great deal of care devoted to subtle gradations of shading, as this will come later in the process of engraving. Although it will obviously be a half-tone version of the finished work, you should have a pretty clear picture in your mind of the effects you wish to convey. You should also have experimented

with techniques on a small piece of board initially. This is the stage at which the major decisions can be made and alterations, should they be needed, do not present any problems. If your ideas do not seem to come across quite as effectively as you visualized them, do not be reluctant to discard the original sketch and start again, perhaps approaching the subject in a slightly different way, until you feel certain that it is absolutely *right*. Once involved in the actual engraving, it will not be so easy to make changes.

Your preliminary study can be in ordinary black pencil on white paper,

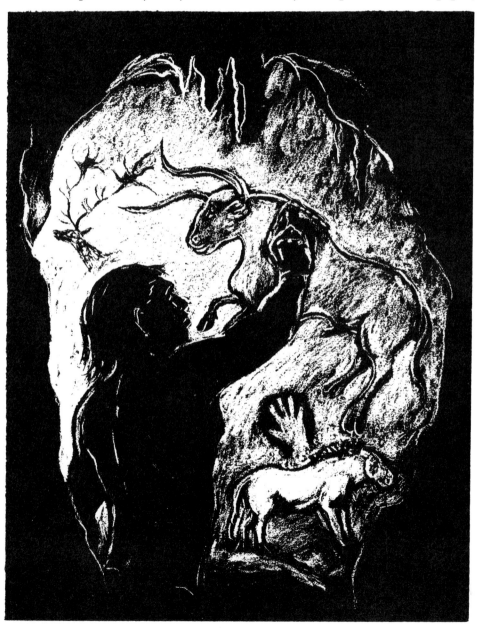

67a Preliminary drawing, white pastel pencil on black cartridge paper

but you may find it useful to work with a white pencil on black cartridge paper and thus get a better idea of the finished effect. If using the latter, it is far better to choose the pastel type of pencil, provided you can obtain one, as the white is much more pronounced and easier to erase if required. Beware of putting too sharp a point on one of these, as it will almost certainly break immediately! Lines can be corrected or defined more clearly with a black pencil, preferably *not* the lead variety as these give a distracting shine, but one which is included in a range of colours. This can be applied over the white areas where there is important detail. For the purposes of the demonstration, I have used this method in my preliminary drawing (67a). In either case, an erasing shield is an indispensable gadget, being a very thin piece of metal with several shapes cut out which allow the accurate removal of small areas without disturbing the rest. Once you have become familiar with the medium, an ordinary pencil sketch should, in most cases, be sufficient. This depends on the complexity of your design, as there might be instances where there is an advantage in doing both versions. Some exponents even recommend the painting of white lines on black paper, although this would seem rather laborious. Of course, with the necessity to redraw the subject so many times, there is the danger of losing the spontaneity of the original sketch, which must be guarded against.

Preparing the board

This must be carefully cut out with a sharp knife and metal rule to guide it. *Never* use scissors, as the board will crack. It should be at least 1 cm ($\frac{3}{8}$ in) or so larger at each side than the size of the drawing. As the material is so fragile and easily damaged, it must then be mounted, so you will also need to cut out a piece of heavy cardboard in the same size. The corrugated type is lighter though strong and easier to cut but should be a smooth piece which has not previously been bent. The two must now be glued together using a thin, even coating of rubber cement or other bonding agent, following the instructions on the container. An aerosol spray of bonding adhesive such as the kind used for mounting photographs may also be used, but very great care should be taken during spraying, with the surrounding area well-protected, otherwise everything within its range will be affected. Black scraperboard/scratchboard must not be handled any more than is absolutely necessary during this procedure as it marks very easily, and a clean sheet of paper should be placed on top when pressing it firmly to the mounting board.

Tracing and transferring the design

Now you are ready to trace your sketch with tracing paper cut to a slightly smaller size than the board, allowing space to fix it in place with small strips of masking tape at the top corners only. Using a red ball-point pen, or well sharpened red pencil, carefully trace your drawing. Apply white chalk or pastel pencil to the reverse side, making an effort to restrict it to the lines as much as possible to avoid getting an excess of white on the board; if preferred, white carbon paper may be used. With the tracing securely fixed to the board, go over the lines with a black pencil or pen, checking to see how much pressure is needed for a clear transfer, as too much will indent the scraperboard/scratchboard, particularly from a pen. By changing the colour, you can see which parts are completed. This can also be checked by lifting the paper now and then to make sure that all lines are clear. There may be some areas outside these which have picked up some of the chalk, but these can easily be removed with the tip of your finger.

The tracing process, though admittedly somewhat tedious, has certain advantages in that it affords another opportunity to reassess your design. Seeing it only in outlines, aspects of the composition become more obvious. Turning it over and viewing it in reverse makes anything which may be slightly 'out of drawing' doubly noticeable, as in a mirror's reflection. When I had completed my tracing (67b) I decided that the 'hand signature' would be far better moved to the upper part of the picture as it detracted from the intricate workmanship on the bas-relief. This alteration also left more scope to interpret a rougher texture on that area of the cave wall.

67b Tracing—note change in location of 'hand print'

The engraving

You are now about to embark on an exciting, visual voyage of discovery as you see the vague image taking form, scraped out of the depths of pure black. It must be emphasized that work done on black scraperboard/scratchboard should *never* be treated as merely a white outline drawing, a tendency so frequently encountered with the novice. In fact you should make a point of avoiding unbroken outlines at the start, even though the temptation is to secure the soft, chalk lines quickly. Make the effort initially to build a faint tone around or within an object with dots or short dashes, keeping the work flexible at this early stage. Of course, some fine outlines will be necessary, but many of these will require breaking up later with a pen or small brush.

Assuming you are right-handed, it is better to start your engraving from the lower right of the picture, leaving the upper left-hand areas until this portion has at least been partially scraped so that you do not eradicate

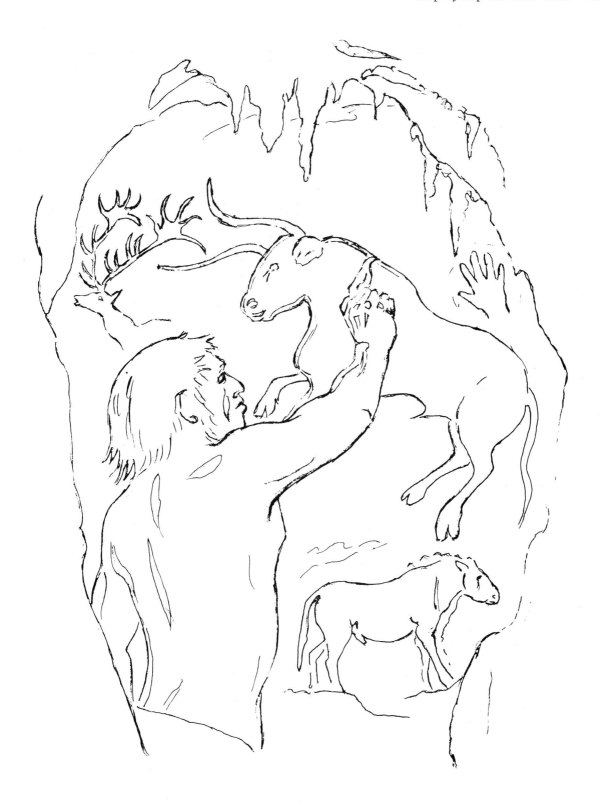

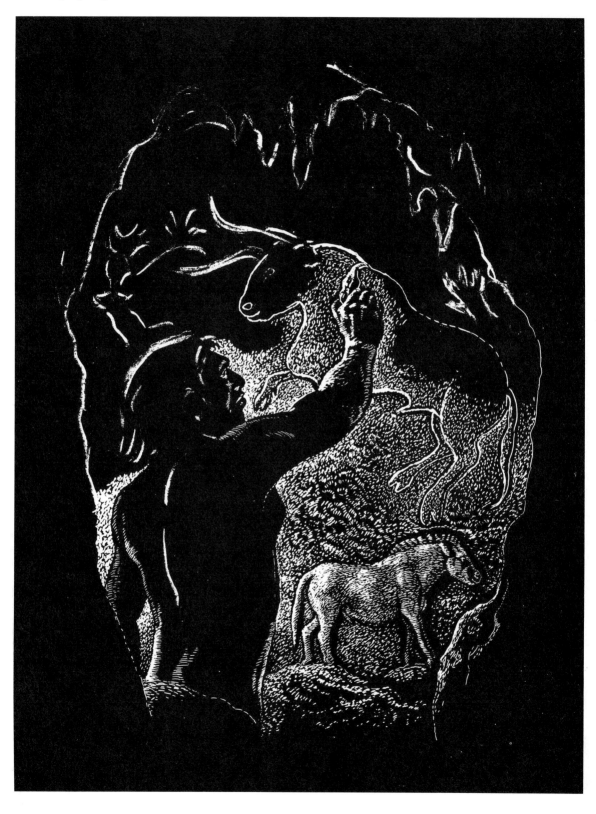

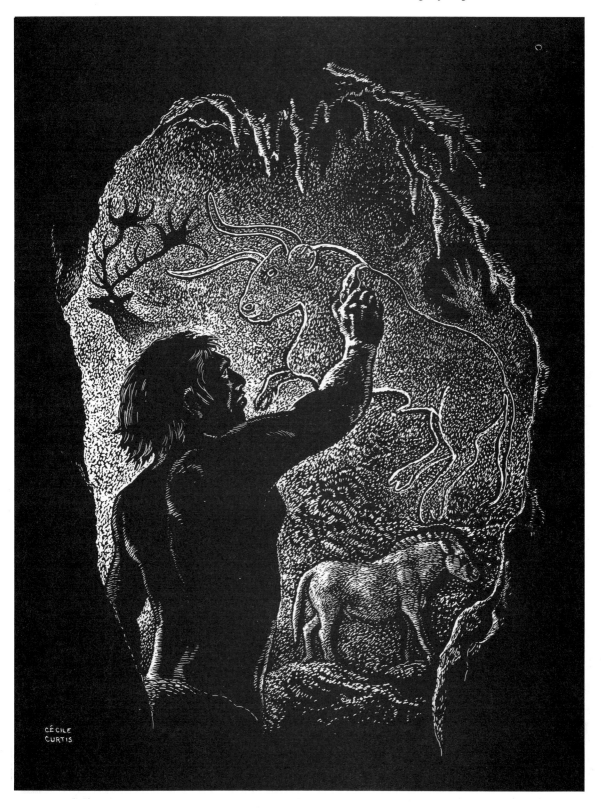

the faint, white guide lines with your hand. As you proceed, these can usually be rubbed away, though occasionally a few may still be visible and will need to be inked out later. Always keep a clean sheet of paper under your hand as you progress upwards to avoid filling the engraved areas with black dust scraped from the board. It should be constantly blown off as you cut and a soft brush will clear away any traces that remain.

The next illustration (67c) shows the design partially engraved. Having started at the lower right, I gradually moved up and over to the left, going back and forth to build up tones and compare them with other areas to maintain the consistency of the light source. I have restricted the technique on the wall of the cave to a coarse, uneven stipple, using the cutting edge as well as the point of a short-bladed knife to express its texture. The engraving of the horse is done with the point only. I had to exercise restraint when working on these areas further away from the light, saving my energy for the part where the greatest emphasis will be needed. As I got to the area behind the man's head, the light is at its most intense, the location of the unseen lamp or torch having been planned in my mind's eye to highlight the centre of interest — the artist's profile and his creation. The lighting on his skin is done with a fine scalpel except for the brighter area on his forearm and hand which draws the eye up to the engraving of the aurochs.

Here the scraperboard/scratchboard engraving is complete (67d). Stalactites in the ceiling catch light from below but are kept less prominent with subtle definition, the shadows they cast helping to outline their form. The painting of the deer is kept subordinate as well so as not to rob the man's portrait of its strength. One of the golden rules in illustrating is: 'always make things easy for the head'!

The examples in this demonstration are only reduced to slightly over half the size of the original to minimize any loss of detail.

67c Engraving partially completed, faint guide lines visible at the top of picture, overall size slightly extended to give more scope

67d Completed engraving. Reduction is 70% of the original size

5 STEP BY STEP ON WHITE BOARD

We will now explore the relatively unknown territory of white scraper-board/scratchboard, progressing from the pencil study to the finished product.

I have selected a pair of dogs for the subject matter mainly for its universal appeal, bearing in mind the fact that many artists as well as laymen own pets or know someone who does, and might like to start with an animal portrait. I have chosen a particular black Great Dane, not only because, in my opinion, he is the most beautiful dog in the world, but also because he happens to be *mine*. As such, he has the added advantage of being readily available for close observation. Having decided on the angle I wish to use, I sketched in roughly the desired pose. I then sorted through dozens of the snapshots I have taken of him to see which, if any, come near to what I want. None of them does, as is usually the case, but bits of one or another may be useful for checking on a particular outline or anatomical detail during the considerable time that he spends sleeping while I wait for those fleeting glimpses when he shifts his position.

As this example is to demonstrate the use of black line technique on white in combination with the reverse, I am using a West Highland terrier belonging to a neighbour. Being small and white, she provides an interesting contrast and possesses quite a different type of fur from the smooth, black velvet of the Dane's.

Preliminary pencil study

The working drawing for white board involves somewhat more than that required for black. Not only must all the areas of light be indicated, but also the dark. In the engraving, some of these light parts will be shaded with a very small application of black and much of it will be treated as a pen and ink drawing to give variation or a difference in texture. The Great Dane must be painted in solidly with black to create only a silhouette. Within this shape, the highlights and shading should be planned, though their finer subtleties are not indicated at this stage, merely a bold definition of them. In the sketch (68a), for which I used only an HB pencil, the Dane is far from black and the sheen of the fur is shown as white, perhaps giving the impression that the animal is grey. It is done in this manner to make the tracing easier as it is, after all, only a *working* drawing. To have

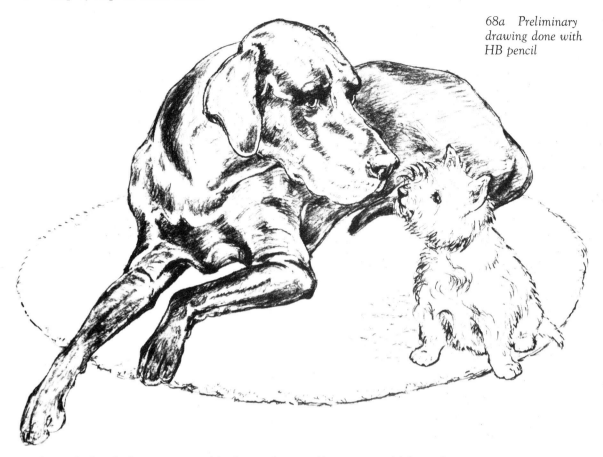

indicated the darkest parts as black, as they really are, would have been a waste of effort.

The elipse formed by a round mat seen in perspective will not require more than a slight amount of stippled shading, as its purpose is simply to enclose the two figures and give a pleasing overall shape to the composition.

Tracing and transferring

Having prepared the board as described in the previous chapter we are ready for the next stage (*68b*). With two well-sharpened coloured pencils, or ball-point pens, the outlines are traced—a red one for all the areas to be filled in with black and also those which will just be dots or lines, then, afterwards, the parts to be scraped out to varying degrees of light are traced in green. At this point, the profusion of these patterns may seem confusing, but a quick reference to the sketch will sort them out.

The tracing is now fixed to the white scraperboard/scratchboard with either small pieces of masking tape, as described before, or drawing board

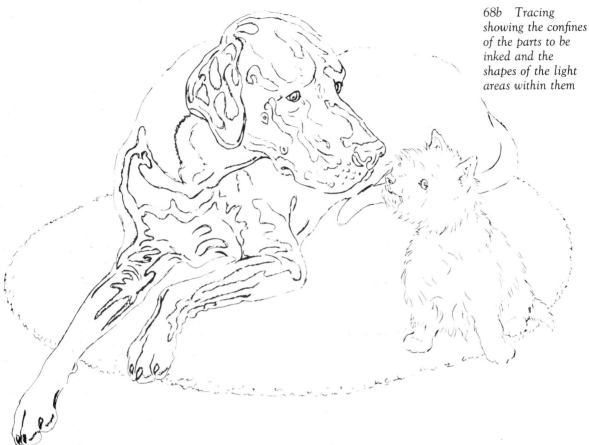

clips. It is a good idea to make light pencilled register marks on the board around the top corners of the paper as it will have to be repositioned accurately later on. Now a piece of black carbon paper is placed under the tracing with a sheet of 'flimsy' paper in between so that when you go over the *red* outlines with black, you can see exactly what has been transferred.

It is better not to mix pencilled and penned lines for your tracing as the pen will not leave a mark very readily on coloured pencil, so choose one or the other.

Inking

Having removed the tracing, you should now have all the information needed to start inking in the black areas and lines. These can be initially reinforced with a technical pen which will speed up the filling-in with a brush. For this example I have used a Faber-Castell TG1.S with an 0.35 mm drawing cone before applying the drawing ink with a number 3 watercolour brush, changing to a number 1 for the smaller areas on the white dog. It

is very important that the black is solid, because not only will it make the engraving more effective, but it will also print more clearly. It is best to fill in as quickly as possible, but care must be taken to see that the coating is never thick, as it will crack and not scrape out cleanly. If some parts do not appear sufficiently dense, then you can go over these lightly after the first coating has dried. This must now be left to dry *completely* before being cut into. There is, naturally, an enormous temptation to start immediately, but this must be resisted. When you think it is dry, give it another five minutes at least, especially if the atmosphere is damp.

After whitening the reverse side of the tracing where the *green* lines are, or, alternatively, using white carbon paper, this is placed on the drawing again using the pencilled register marks you have made to locate the previous position exactly, as, in inking the lines they may have been altered fractionally. By going over the green with black lines, they are transferred within the inked-in silhouettes. As these can sometimes be quite small, any excess traces of chalk or pastel pencil could be misleading so, if this method is used, it is advisable to blow on the reverse side of the tracing and shake it gently before placing it on the board.

Engraving plus pen and ink

As with black scraperboard/scratchboard, the engraving should commence in the lower right-hand corner (or the reverse if you are left-handed) to keep the light guide lines intact. Working upward from the black dog's left front paw, I have engraved fine lines to express the form of the leg and part of the chest, progressing to the more complicated textures on the face. I have used the point of the scalpel thus far, changing to a stencil knife for the grey part of the muzzle. The grained texture of the nose was done by lightening the top with short dashes over which I used a pen in the opposite direction. Although I have drawn and painted this subject on many occasions, every new pose presents slightly different problems. His coat is so short and fine that it is difficult at times to decide in which direction the hairs lie and I need to examine him closely.

The shaded portions of the little 'Westie' are only indicated with a small amount of solid black at this stage (68c), but will be increased after the Dane is nearly complete so that a fair comparison between the two is possible. The white hair is thick and wavy, tending to hide the form underneath which needs to be conveyed with careful rendering. The breeds most ideally suited to scraperboard/scratchboard technique are, of course, the spaniel group (see illustration 116) whose luxuriantly waving tresses of both short and long hair easily suggest the way in which the lines should be cut; but we are dealing here with contrasts in colouring as well as coat to suggest the techniques possible in the treatment of each one. When cutting several lines in the same direction, it is often easier to be

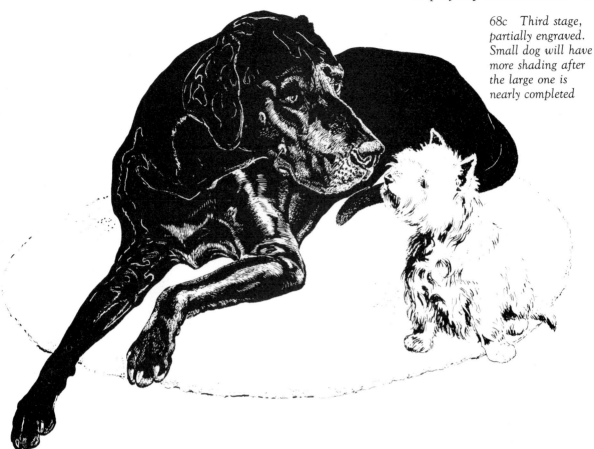

able to turn your drawing board around at different angles. For this reason I prefer to use a smooth piece of hardboard with well-sanded edges onto which I clip the scraperboard/scratchboard, as it is light in weight and easy to handle while still providing a firm backing.

When working on a portrait of a person, one tries to attain not only a good likeness, but also the right expression. Without wishing to inject a note of anthropomorphism, the same applies when portraying an animal. An examination of the gorilla in illustration 103, and also the orang-utan on the back jacket, will bear this out, particularly in the expressiveness of the eyes.

I have observed that when something has caught my Great Dane's attention, the normally smooth dome of his forehead has velvety furrows, the apertures at the sides of the nostrils are dilated and the ears turned slightly outwards with the hairs more erect at the base. All of these points, coupled with a noticeably intense look in the eyes emphasized by the tension in the brows, contribute a life-like quality to what would otherwise be merely a graphic representation.

Those expressions which we equate with certain changes of mood in the human face do not necessarily mean the same thing in animals, but

*68d Completed
engraving, reduced
to 50% of original
size.
260 mm × 350 mm
(10 in × 14 in)*

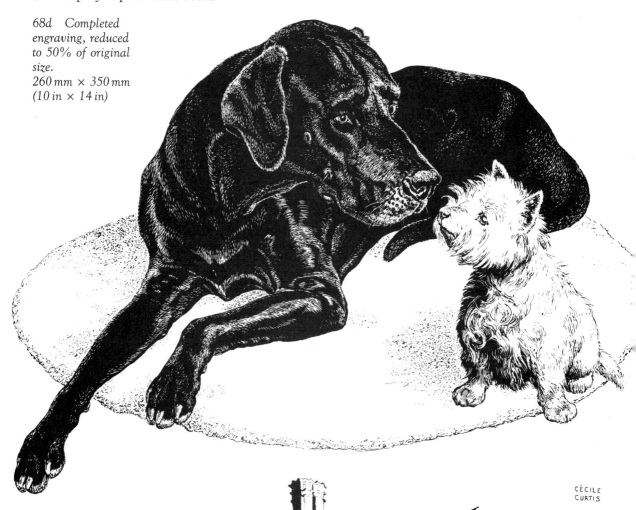

CÉCILE
CURTIS

*69 Princeton
University,
architectural detail,
showing the stage
where inking is
nearly completed.
Inner guide lines
have not yet been
added*

there are many which do. Although animals do not 'smile', a flick of the
brush at the corners of the mouth, where appropriate, can often impart
a cheerful or contented aspect without any suggestion of caricature. I
looked for this when drawing the face of the West Highland terrier, where
the convenient tufts of hair at the sides of her mouth provided just such
an opportunity, as I wanted to convey a friendly encounter, with no
intimidation involved.

After completing the engraving of form and highlights on the front half
of the black dog, I started working on the white dog's head, the area
behind having been left solid black to enable me to extend the white hairs
over it. I then increased the amount of black shading in the fur to give
the body more solidity, engraving a few lines into it to express the silky
texture, and added more black lines to the lighter half with a pen. Some

70b Newcomen library completed. Illustration for Kings Chapel *by the Rt. Rev. Oliver J. Hart (The Newcomen Society in the United States), 260 mm × 225 mm (10¼ in × 8¾ in), reduced to one half the size of the original*

more definite stippling in the shadows on the mat and a restrained lighting on the back of the Great Dane completed the picture (68d). The original in this demonstration is twice the size in order to include more detail.

6 THE ADDITION OF COLOUR

Any well-executed scraperboard/scratchboard engraving should stand on
its own merits, portraying form, tone and texture in a medium which has
only pure black or white to express them. Only occasionally does it profit
by the addition of colour and in most of these instances it is best when
limited to only one.

Book illustrations and jacket designs often fit into this category when
a second colour adds to their impact. Yellow or any pale shade is
unsuitable as it must be one which can be scraped out or engraved in just

*71 Another
illustration for
Samantha and the
Swan (Hodder &
Stoughton),
315 mm × 228 mm
(12½ in × 9 in),
in black and
viridian green, here
printed in grey*

THE FIRST BOOK OF
CAVES

by ELIZABETH HAMILTON

72 *Jacket design for* The First Book of Caves *by Elizabeth Hamilton (Edmund Ward). The same green was used here with black which was printed in a very dark blue*

the same way as black, so a strong, deep hue of pure colour is essential in order that the lines are clear and sharp. It can be utilized in a strictly decorative way or else bear some relationship to the natural overall colouring of the subject matter itself. A typical example of the latter can be seen in colour plate 1 where a bright orange is used in three different ways: firstly, independently, when painted in a line technique such as the water lilies as well as the lightest tail-feathers and wattle of the crowned crane; secondly, with orange-on-black as in the darker feathers and the body of the wildebeast which were filled in with black, scraped out and then the orange applied over this, and finally, where the coloured ink is engraved and fine touches of black added afterwards with a pen to the delicate plumage of the crane's *coiffure*. The lions in colour plate 5 were scraped out twice, first from a small amount of black shading and, secondly, after covering with orange ink.

LANDSCAPE
WITH
CHURCHES

C·M
DURANT

LANDSCAPE
WITH CHURCHES

C.M.DURANT

MUSEUM
PRESS

73 *Jacket design
for* Landscape with
Churches *by C.M.
Durant (Museum
Press) done in green
and black*

74 *Green was again the second colour in this double-spread illustration for* Samantha and the Swan *(Hodder & Stoughton).*
230 mm × 460 mm (9 in × 18 in)

75 *Double-spread illustration for* He Looks This Way *(Frederick Warne), 165 mm × 470 mm (6½ in × 18¼ in), in which the only part in colour was the beetle on the foreground leaf. A bright orange prevented it from being lost in the composition*

CECILE
CURTIS

The illustration in colour plate 4 demonstrates the employment of a second colour, in this case cobalt blue in the original, using it merely as a background. It was printed as violet in the book where both appeared. Here I wanted to impart the coolness of an African night as opposed to the warmth of orange for the daylight scenes.

In this picture of a small girl with a swan (*71*), the second colour was viridian green, here printed in grey, which was really a means of separating the two subjects literally, as well as symbolically. The fresh, cool green suggested the watery realm of the swan, and black and white the domain of the child, the two creatures cautiously advancing to meet each other from their different worlds. The colour was used in a decorative sense in the bramble leaves, being washed over their black shading to create the impression of a much darker shade. This effect can be seen more clearly in colour plate 6 from the jacket of the book in which the same green featured throughout. The foliage of the tall tree on the left and the shadowed area of the river are again a combination of colour on black.

The grey areas in this jacket design (*72*) were also viridian while the black ink was subsequently printed in a deep blue, a very effective combination for the damp, chilly interior of a cave.

76　Jacket for Panda *(Frederick Warne), 192 mm × 295 mm (7½ in × 11½ in), the actual size of the original illustration of the panda itself which was printed 'same size' for the jacket. Some of the lettering was in bright red*

大熊猫

PANDA

CÉCILE CURTIS

WARNE

PANDA

CÉCILE CURTIS

In the next example (73) it was an obvious choice, this time creating the aspect of a sunlit landscape against which the church buildings stand out. Indeed, the same principle is also evident in the illustration of three goats (74) where the tempting weed and leaves of the apple tree could be left a mainly solid green, giving prominence to the animal in the foreground.

There are instances of using colour where it is necessary only as a means of emphasis for some one thing which would otherwise have been lost in a composition involving a great deal of other subject matter. In this group (75) a close-up view of the beetle on the foreground leaves was painted in bright orange with all the background being portrayed in black only.

The design for the book's cover as well as the jacket of *Panda* (76) consists of one of its illustrations reproduced in the size of the original. I made a separate drawing in black of the Chinese characters for the back which, in translation, means: 'big bear-cat'. These were printed together with the title in bright red to give an eye-catching splash of colour.

When applying colour to scraperboard/scratchboard, it is generally safer to use drawing ink as it goes on more smoothly with less tendency to crack than other media. Being of a thinner consistency, it will scrape out with greater ease and accuracy. The only disadvantage is the difficulty of maintaining a uniform distribution of tone in large areas; however, this will print as a matt finish and any slight irregularities that are noticeable in the original will disappear as it will be reproduced in line rather than half-tone.

Experimentation

In producing work which is intended for reproduction, there are certain rules and precautions which must be observed and you should constantly keep in mind its suitability for printing. It can be a very heart-breaking experience to invest hours of painstaking, detailed work on something which loses most of it when printed. Coloured ink must be engraved as clearly as when using black, avoiding extremely fine lines and cross-hatching. There are exceptions, however, where none of these restrictions needs apply. These are the occasions when one is inspired to create a work whose sole objective is to achieve something interesting and unique with none of the usual inhibitions associated with commissioned illustrations.

Through adventurous experiments one can discover beautiful, exciting effects with a selective use of one or more colours. The engraving of the Spanish farmer *Tio Pedro* in colour plate 2, previously discussed in the section on portraiture, was just such a departure. Through a series of preliminary trials, I had found that a certain proportion of brightly-coloured ink mixed with black to the point where it appeared *almost* black when applied could be just partially scraped away, leaving a subtle tint

where the colour had stained the surface. This could be lightened still more with increased scraping, and highlights obtained, of course, by the complete removal of what remained. The result was a soft 'glow' of colour combined with the technique of a wood engraving. I used a crimson ink for the head and a yellow-green, its near opposite, for the background.

This experiment was carried still further in the study of the orang-utan on the back jacket which involved the use of four colours mixed with black to emulate the subtle variations of grey-blue, reddish brown, yellow and pink. The motivation in selecting this appealing subject came to me when I was working on others at London Zoo. As always, I was both fascinated and, inevitably, saddened, by the melancholy expressions of these unfortunate inmates of the Ape House who, in many cases, were the victims of unscrupulous animal dealers and the poachers who often captured them as infants after killing their mothers. They were lovingly looked after and carefully supervised by the head keeper who very kindly arranged for me to visit one, 'back stage' so to speak. I was introduced to an adult female in the corridor behind her cage where I waited uncertainly while she left her titian-haired offspring to greet me. She moved toward me in a slow, deliberate shuffle, flung one very long arm around me and kissed me with her velvety lips. Such close contact as this allowed a far more detailed observation than I could ever have hoped for! Sketching her later outside the thick plate glass which protects all the great apes from their visitors, I had gained ample insight into the intricasies of this expressive face. The combination of those studies and additional drawings of her neighbour, a fine young male, gave me splendid material with which to create the finished portrait.

I had been deeply moved by the eloquence of their expressions and very much wanted to interpret this in what seemed an ideal medium. I was therefore immensely gratified when it found a place in an exhibition at the Society of Wildlife Artists and was later produced as a fine arts print with part of the proceeds going to help those few creatures which still remain in their dwindling habitat.

The design for a record sleeve, *Swan Lake*, on the front jacket, incorporates the same technique of partially scraped out colour in the figure of the ballerina, the swan being engraved in the more traditional manner from a solid silhouette of vandyke brown.

Two different browns were the colours used in the composition *Tia Luisa* in colour plate 3. Here I experimented with another technical variation. As the inks had to be spread over a large area and would leave the inevitable uneven streaking, I utilized this tendency in a positive way by suggesting the grain of wood and applying them diagonally across the board, thus also giving the impression of hazy, dust-filled sunlight, which seemed appropriate.

This then is the case for the addition of colour, at times very effective when applied with discretion. It can certainly be used to advantage in

scraperboard/scratchboard engraving but should only be considered on occasions where a second colour contributes significantly to a work and there is no objection to the extra expense incurred in printing an additional line block. The examples cited under the heading of 'Experimentation' were motivated by the purely artistic effects which could be created, since this style of engraving needs to be reproduced by full-colour half-tone printing methods.

7 TRICKS OF THE TRADE IN ILLUSTRATING

Wherever your ultimate ambitions may lie in the field of illustration, it is advisable, if not essential, to include a substantial selection of line drawings in your portfolio, simply because they can be printed more economically than any other form of art work. They are good material for use not only in books, but also in many other types of publication. All sorts of pamphlets, informational leaflets as well as magazines and newspapers use them, especially in advertisements, which will be discussed in the next chapter together with other commercial outlets.

Except for children's literature, the illustrated book is most likely to be non-fiction, which can cover a whole range of subject matter. Scraperboard/scratchboard is perhaps unique amongst artists' media in that it can often appear better in a reproduction than in the larger original. The image is somehow sharpened, similar to the refocusing of a camera lens, or the greater clarity of a small photograph as compared with an enlargement of it. The exceptions are when there are very fine lines or cross-hatchings. When accepting a commission, the illustrator would be wise to enquire about the size in which the work is to be reproduced, and particularly the quality of paper on which it will be printed. The most faithful of reproductions are those on smooth 'coated' stock, the worst being a rough sort of paper which behaves rather like a blotter, spreading the black lines and filling in the finer white lines engraved in the black areas.

The picture of a stained glass window (77) had to be printed in the

77 Illustration using woodcut technique for That We May Know! by Leslie Glenn (The Newcomen Society in the United States). 86 mm × 97 mm (3⅜ in × 3⅞ in)

size shown here. As there was much detail which would be lost from a very large original with finely engraved lines, I chose a more open, woodcut technique using the multiple tool sparingly in the border design. Except for the halo, the rest of the panes were scraped out from black.

In a book which featured St John's, known as 'Church of the Presidents' in the US capital, I sketched it from two opposite viewpoints. The first, at an oblique angle (*78a*) shows its proximity to the White House in a distant view of the latter with an equestrian statue and cannon in front. The second is from the vantage point of the White House itself (*78b*) where these two became the dominant subjects in the foreground. The reduction in both illustrations is considerable as I needed to work on a fairly large scale to be able to include a great number of points of interest. I therefore avoided many areas of solid black, giving it a light and airy look which minimized any possibility of problems in the reproductions.

78a and 78b Two views of the 'Church of the Presidents' illustrations for That We May Know! *by Leslie Glenn (The Newcomen Society in the United States). 270 mm × 260 mm (10⅝ in × 10 in) and 203 mm × 320 mm (8 in × 12⅝ in)*

The expedient of the cast shadow

The entrance to a college library from a dim hallway (79) was a subject totally lacking in the necessary contrast of light and shade. I had to wait for the moment when the sun shone through the fanlight of the front door, casting a shadow of itself as well as that of a ceiling lamp, to lend sparkle to the composition of an otherwise monotonous subject.

79 College library entrance (Newcomen publication).
190 mm × 175 mm
(7⅜ in × 7 in)

Graham Sutherland's figure of an angel at the front of Coventry Cathedral (80) was incorporated in a paperback book cover where the reproduction had to be quite small. Here, I again used a woodcut technique which would reduce easily and encouraged a three-dimensional effect with the black cast shadow in which the stone work of the building can be seen.

This expedient can be a most beneficial factor in showing architectural detail to its best advantage. The uneven texture of this ancient house and passageway (81) on a narrow Venetian canal is greatly augmented by the slanting sunlight, which also helps to bring the bridge to the forefront.

A vignette style of presentation is often improved by a pattern of shade, thus creating a more interesting outline. This ornate colonial doorway in New Hampshire (82) is a good example. It is also a means of introducing

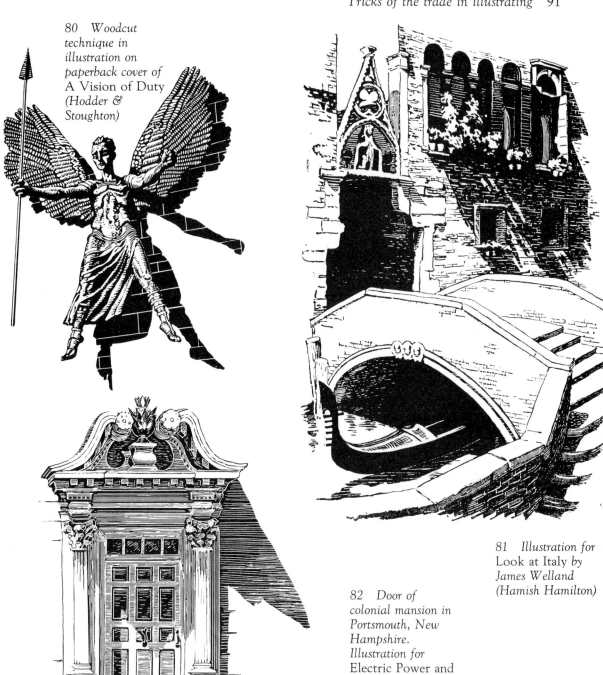

80 *Woodcut technique in illustration on paperback cover of* A Vision of Duty *(Hodder & Stoughton)*

81 *Illustration for* Look at Italy *by James Welland (Hamish Hamilton)*

82 *Door of colonial mansion in Portsmouth, New Hampshire. Illustration for* Electric Power and History in Southeastern New Hampshire *by R.C.L. Greer (The Newcomen Society in the United States)*

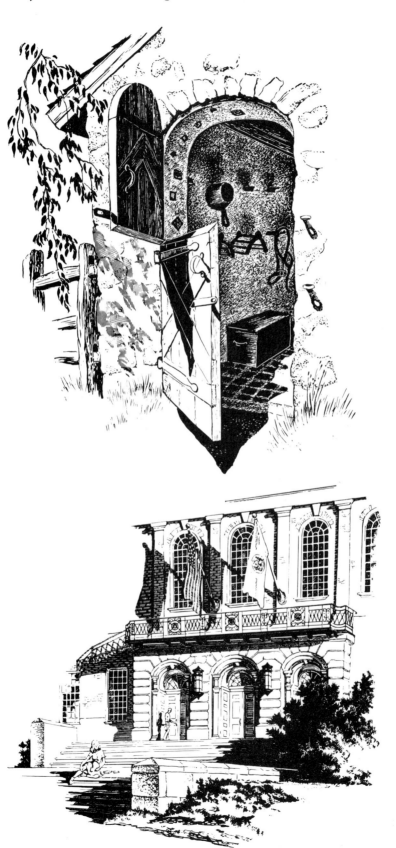

83 *Chapter
separator for*
Chester County
Cookery *(Princeton
University Press).
203 mm × 150 mm
(8 in × 6 in)*

84 *Façade
of university
building (Newcomen
publication)*

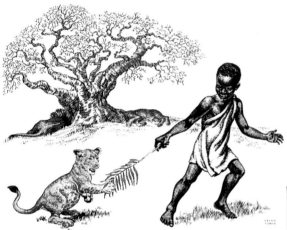

4 Illustration for *He Looks This Way* (Frederick Warne)
 180 mm × 490 mm (7 in × 19 in)

5 Illustration for *He Looks This Way* (Frederick Warne)

6 Jacket design for *Samantha and the Swan*
 (Hodder & Stoughton)

DRYAD

A delightful design to engrave and colour.

Colourfoil Kit

DRYAD

Create your own beautiful pictures
in 3 different finishes

Scraperwork Compendium

Créez vous-même vos belles gravures dans 3 finitions différentes

CONTENTS
Scraperboard Black 10" x 8"
Scraper Cutter No.1
Aluminium Scraperfoil 10" x 8"
Scraper Cutter No.2
Scraper Scraperfoil 10" x 8"
Scraper Holder
Scraperboard Black 5" x 8"
Tracing Paper 10" x 8"
Aluminium Scraperfoil 5" x 8"
Copper Scraperfoil 5" x 8"
Instruction Leaflet

CONTENU
Carte Scrapeboard noire 10" x 8"
Couteau racleur No.1
Feuille Scraperfoil aluminium
10" x 8"
Couteau racleur No.2
Feuille Scraperfoil cuivre 10" x 8"
Porte-racleur
Carte Scrapeboard noire 5" x 8"
Papier calque 10" x 8"
Feuille Scraperfoil aluminium
5" x 8"
Feuille Scraperfoil cuivre 5" x 8"
Notice explication

INHALT:
Kratzvorlage, schwarz, ca
25 x 20 cm
Rottiermesserrenutz Nr.1
Aluminiumkratzfolie, ca
25 x 20 cm
Kratzmesserrenutz Nr.2
Kupferkratzfolie, ca 25 x 20 cm
Kratzmesserhalter
Kratzvorlage schwarz ca
12,5 x 20 cm
Pauspapier schwarz ca
12,5 x 20 cm
Flusspapier ca 25 x 20 cm
Aluminiumkratzfolie, ca
12,5 x 20 cm
Kupferkratzfolie, ca 12,5 x 20 cm

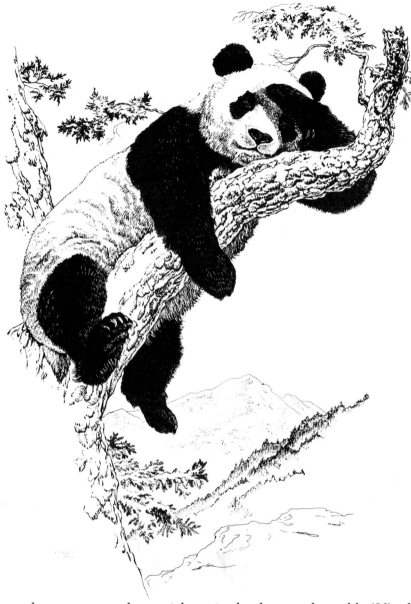

85 *Illustration for
Panda (Frederick
Warne),
380 mm × 265 mm
(15 in × 10½ in),
in which most of the
composition was
rendered with pen
and ink using a
No. 0.20 Rotring
Isograph. Yes, the
giant panda really
does sleep like this!*

other textures and materials, as in the door to the stable (83) where tiles, wood and walls are more distinguishable in the darker areas.

On the façade of this university building (84) strong sunlight again plays an essential role in bringing out the forms of the doorways, steps and balcony as well as showing off the flags more prominently. The overall brickwork is suggested with a multiple tool, confining it to small areas.

In this study of a giant panda napping in a favourite place of refuge (85) I made a point of limiting engraving techniques to a minimum, using mainly a delicate treatment with pen and ink in order to draw more attention to the small area of shade supplied by a protective paw.

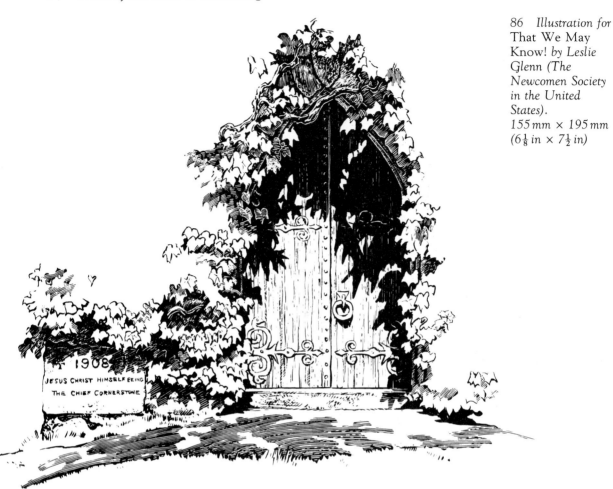

86 *Illustration for*
That We May
Know! *by Leslie
Glenn (The
Newcomen Society
in the United
States).*
*155 mm × 195 mm
(6⅛ in × 7½ in)*

Notice the door of a church (86), whose walls were heavily grown over with vines, is endowed with more character by the patterns they cast upon it and I was able to leave the surrounding area white.

Of course there are instances when shadows have to be invented where none would exist in reality. This small spot drawing (87) was used to illustrate an incident in the early history of York Harbor, Maine. A suspected witch was burnt at the stake and later, after being posthumously found innocent, she was honoured with a grave. I had to do an illustration

87 *Witch's grave
at York Harbor,
Maine, illustration
for* That We May
Know! *by Leslie
Glenn (The
Newcomen Society
in the United
States)*

of her worn headstone whose inscription and carving were barely visible, so the solution was to introduce her shadow falling across it.

Another example of such an invention is shown in this Nativity scene (88) where it is used as an aid in the composition to draw attention to the central figure of the Madonna and child by means of the dark area behind them. Other compositional devices which serve the same purpose are the vertical line of the stall and the horizontal of the door beside her.

Besides casting a convenient means of emphasis for this elegant portico (89), the sunlight brings into prominence its delicate columns. The far railing of wrought-iron was rendered with fine penned lines which were crossed over with a scriber to set it back from the nearer one. Although a limited portion of the colonial mansion is included in the vignette, the small fragment of foliage at the top suggests a tree in the foreground, giving a sense of perspective. Notice the difference when you cover this. In the stark simplicity of the Quaker meeting house (90), so typical of the early American scene, the same applies here with the introduction of foliage, which also gives balance to the picture. Had more of the tree been shown it would have detracted attention from the centre of interest.

89 *Entrance to colonial mansion on the historic Middle Street in Portsmouth, New Hampshire. Illustration for* Electric Power and History in Southeastern New Hampshire *by R.C.L. Greer (The Newcomen Society in the United States)*

90 *Quaker Meeting House, 178 mm × 184 mm (7 in × 7¼ in)*

Psychology of composition

When illustrating children's books, one enjoys a freedom which can be great fun without sacrificing the merits of good technique. It is sometimes possible to convey a situation merely by the point at which one ends the picture and its subsequent positioning on the page. This is known as the psychology of composition.

In my tale of a mouse discovering the wonders of other members of the animal kingdom, many such opportunities arose. Our 'hero's' first view of a giraffe was one of these. My first consideration was to select the most skilful way in which to show the enormous disparity in size without losing the little one altogether! This view (91a) seemed to say what I wanted to say. The mouse is clearly visible and the lower half of the giraffe is allowed to 'bleed' off the top of the page, literally going up *out* of the picture so that your mind's eye fills in the rest of the figure. The two colours somehow help the illusion. All the illustrations were done in black and reddish-brown, at times the colour being used for the mouse or, when suitable, for the other characters instead. Turning to the next page in the book, one sees what he discovered when he climbed up one of these strangely-patterned tree trunks (91b)!

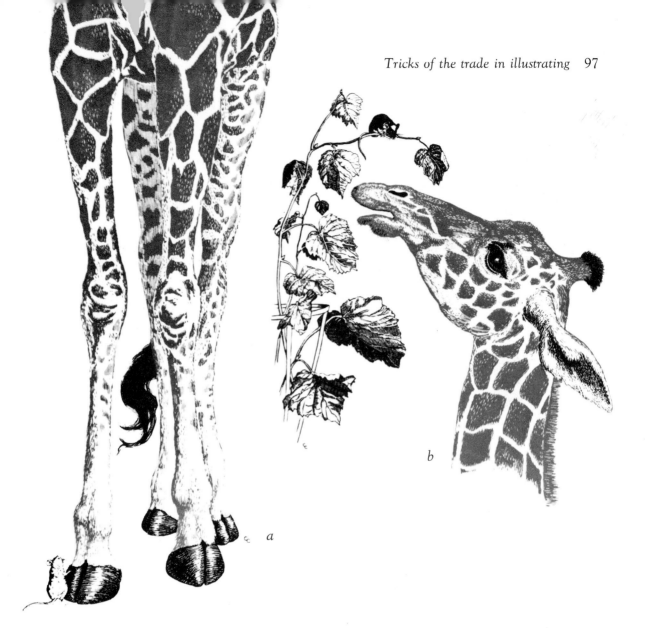

Points of view

The vantage point from which one chooses to view a subject helps to put across an idea or increases the dramatic effect, adding impact to a picture. It is also an excellent means of introducing variety into a series of illustrations dealing with similar subject matter.

The next example (92), where the mouse visits an aquarium, is seen from the point of view of a fish. Here the composition was again printed to the limits of the page at both the top and sides, the upper part scraped out from solid black except for the light underbelly of the fish and the 'hands' and foot of the mouse. Leaving them white defines them more sharply, particularly the parts which come into contact with the outside of the glass. The shells and sand are brown on white.

91a Two-colour illustration for Woody's Wonderful World (Hodder & Stoughton) 420 mm × 185 mm (16½ in × 7¼ in)

91b The follow-up illustration for the same book

92 *From the other
side of the aquarium
glass, another
illustration for
Woody's
Wonderful World
(Hodder &
Stoughton).
345 mm × 315 mm
(13⅝ in × 12⅜ in)*

As a fruit bat spends its resting time upsidedown, I had to catch my
mouse model at a moment when he assumed a similar position at the top
of his ladder for this illustration (93). The wire mesh covering over the
top of the cage was sufficient to complete the composition.

The following example was one of an unusual series illustrating an adult
book of fiction, in this instance, a novella, being less than one hundred
pages in length. All the pictures had to be full-page with a definite border
rather than vignettes with relevant quotations from the text appearing

93 *Indian fruit bat illustration for* Woody's Wonderful World *(Hodder & Stoughton), 375 mm × 275 mm (14¾ in × 11¾ in). On the furred part and eyes of the bat, black was applied over brown ink and the latter scraped out slightly*

underneath. This dramatic incident (94) could also have been presented from a ground level point of view quite effectively, but it would not have been possible to show the look on the baby's face as well from that angle, nor the incredibly long eyelashes of the elephant which are more evident in close-up. This item is featured even more clearly in the earlier example (illustration 6a) and is a detail not usually detected by the casual observer. I once had a discussion with a newspaper photographer about the merits of photographs versus drawings of wildlife and remarked that one cannot see elephants' eyelashes in his type of picture. Just as he was saying that there was no such thing, a young zoo specimen we had been watching emerged from a pool, her eyelashes highlighted by sparkling drops of water!

The composition of the girl sweeping (95) is definitely more effective seen in a bird's-eye view. Except for her hair, all the rest of the scene below was rendered in pen and ink, giving the overhead rafter scraped from black the necessary prominence.

94 Dramatic incident from African Valley *by R.H. Ferry (Frederick Muller). 297 mm × 197 mm (11¾ in × 7¾ in)*

95 Illustration in black with green for Samantha and the Swan *(Hodder & Stoughton). Mainly pen and ink technique*

Black on white plus white on black

One may choose to work on white scraperboard/scratchboard for a number of reasons. Of course it is required both in the employment of the vignette and the use of colour, but it also allows you to have your cake and eat it too in that you can ring the changes from black lines on white to white lines on black, as has been demonstrated, thus introducing more variety in technique and greater flexibility in a composition.

The double-spread illustration of a giant crested porcupine (96) really needed these advantages in order to show off the intricate maze of quills on a black background and at the same time show the animal's dark head and feet against white in a vignette. As in the picture of the fish, I painted a large rectangle in solid black, carefully ducking around the outlines of the quills with a fine brush and pen. The lower ones were just penned on white to create a gentle transition from black.

In this composition with a castellated tower (97) the edifice acquires an atmosphere of mystery on the far bank of the river. Except for the upper outlines, it was scraped out from black which was also a means of defining the foliage of a willow tree on the right. The curious sun dew plant stands out in the foreground, employing the same technique as in the porcupine's quills. The second colour was a viridian green used very sparingly.

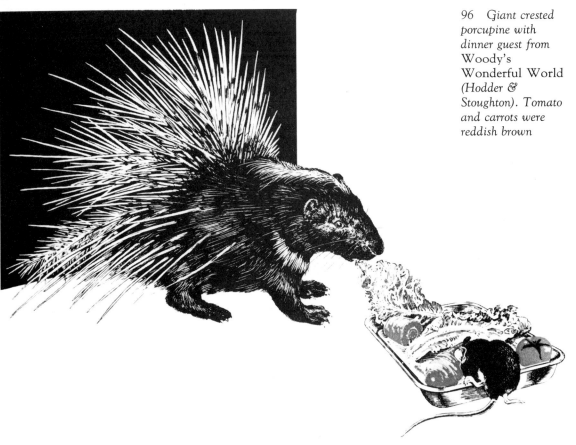

96 *Giant crested porcupine with dinner guest from Woody's Wonderful World (Hodder & Stoughton). Tomato and carrots were reddish brown*

*97 Double-spread
illustration for
Samantha and the
Swan (Hodder &
Stoughton),
293 mm × 365 mm
(11⅝ in × 14⅜ in).
The blue-green of
the second colour
was useful in
defining the water
and gave emphasis
to the darkness of
the river bank above*

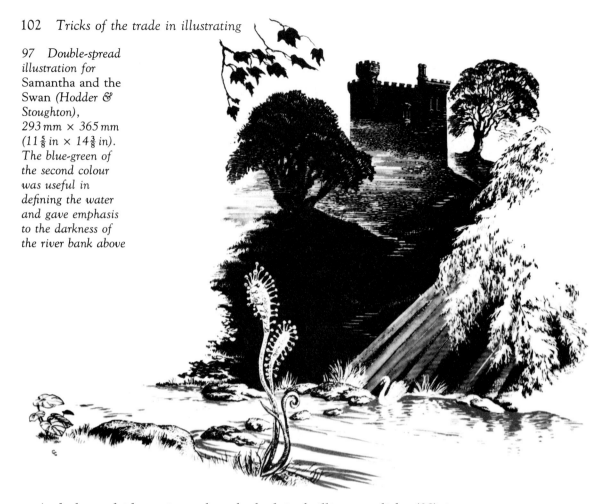

A dark roadside antique shop bathed in brilliant sunlight (98) is a subject which would seem to favour the selection of a black board, but the light was so intense that it was far better to take the rather more arduous course of painting in the black and leave these areas in white, highlighting the delicate figure of the crane, which needed very little shading, as a white silhouette. It would have been somewhat less prominent had it been scraped out.

Another illustration from the short novel was a night scene (99). Once again, black board might have appeared at first to be preferable, but it had been used elsewhere in the book in another moonlight setting. Re-reading the galley proof of the text with which illustrators are usually provided, I noted that the episode I had chosen to depict took place in the early evening when the moon had already risen. I visualized how the lionesses would look silhouetted against a white sky in which the moon could be shown in a patch of black in the clouds scraped to a light tone with the multiple tool. I was able to define the buffalo in the foreground with a restrained use of engraved lines. Despite being on white board, it still possesses a nocturnal feeling.

98 *Chapter
separator from*
Chester County
Cookery *(Princeton
University Press),
reproduced in dark
brown in the book*

99 *Cape buffalo
with lionesses.
Illustration for*
African Valley *by
R.H. Ferry
(Frederick Muller),
297 mm × 197 mm
(11$\frac{3}{4}$ in × 7$\frac{3}{4}$ in)*

This attractive interior of an office (*100*) had a great many points of interest which called for a combination of black and white scraperboard/ scratchboard techniques. The wall opposed to the main source of light was filled in completely with black except for the painting above the fireplace which I left mainly white so that it would stand out from the wall. The problem of ending the composition on the right-hand side was solved by utilizing just the outline of the grandfather clock, a convenient device if you can find an object whose shape is easily recognizable!

In expressing an abstract idea pictorially, scraperboard/scratchboard techniques offer a wide spectrum of possibilities. This illustration (*101*) from a book of essays suggests the destructive nature of man. It relies very much on the facility to create a division of white lines on black combined with the reverse, the version of an early skull being scraped out of black and its modern equivalent rendered primarily in black line on white.

100 One of the offices of the Newcomen Society. Illustration for Kings Chapel by the Rt. Rev. Oliver J. Hart (The Newcomen Society in the United States). 285 mm × 335 mm ($11\frac{1}{4}$ in × $13\frac{1}{4}$ in)

101 Chapter separator for Time Out of Mind *from* The Fields of Noon *by Sheila Burnford (Hodder & Stoughton)*

Extensions and overlays

These two different versions of the same subject may appear to be individual illustrations of the same subject, but there was, in fact, only one. It originally consisted of exactly what is shown here (*102a*), employing the same tactic as explained in the view of the giraffe's legs (*91*) in order to convey a sense of size. When it was subsequently selected to become one of a series of prints, the company that produced them wanted the figure of the king penguin to be shown in its entirety. This required drastic measures. The scraperboard/scratchboard drawing was very cautiously removed from its original cardboard backing—*not* a practice to be recommended very often!—and was then remounted on a larger piece of heavier cardboard, leaving room at the top and left-hand side to add another section of scraperboard/scratchboard. This provided space for the upper portion of the penguin's neck and the tip of its right flipper. I drew in the missing parts and proceeded with the inking and engraving of these additional areas, painstakingly matching up the adjacent lines.

A further amendment was required as it was decided that the selections from this book should be reproduced both with and without the mouse.

I cut out an irregularly-shaped piece of scraperboard/scratchboard which covered the mouse and nearly all of the penguin's left foot. This had to be temporarily fixed to the picture with small strips of masking tape as I did not wish to damage the original illustration which was to appear in an exhibition. I then added the penguin chick, carefully matching up lines once again. As can be seen in the second illustration (*102b*), there is no trace of any division.

There was only one other instance where any revision was needed. This was the portrait of the principal character, the gorilla. Although he only appears at the end of the story, he was my prime reason for deciding to write the book.

Like so many others who have seen this magnificent creature face to

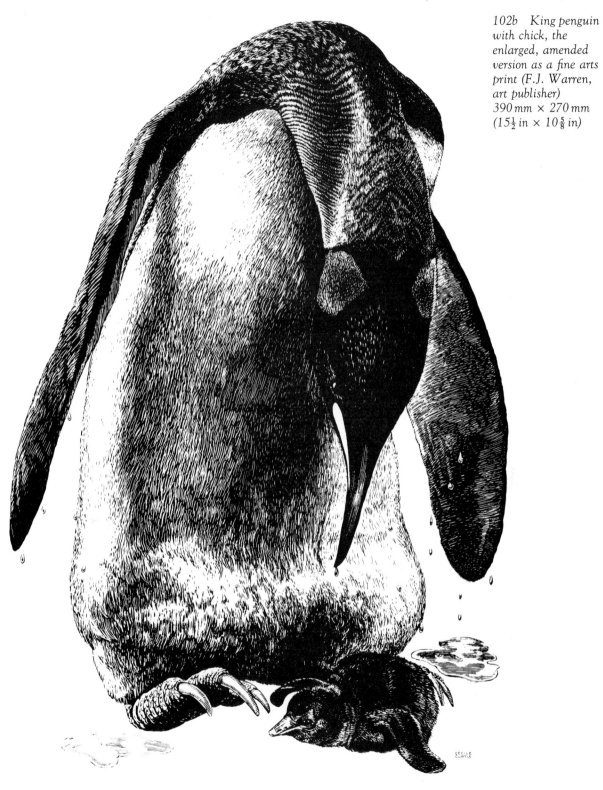

*102b King penguin
with chick, the
enlarged, amended
version as a fine arts
print (F.J. Warren,
art publisher)
390 mm × 270 mm
(15½ in × 10⅝ in)*

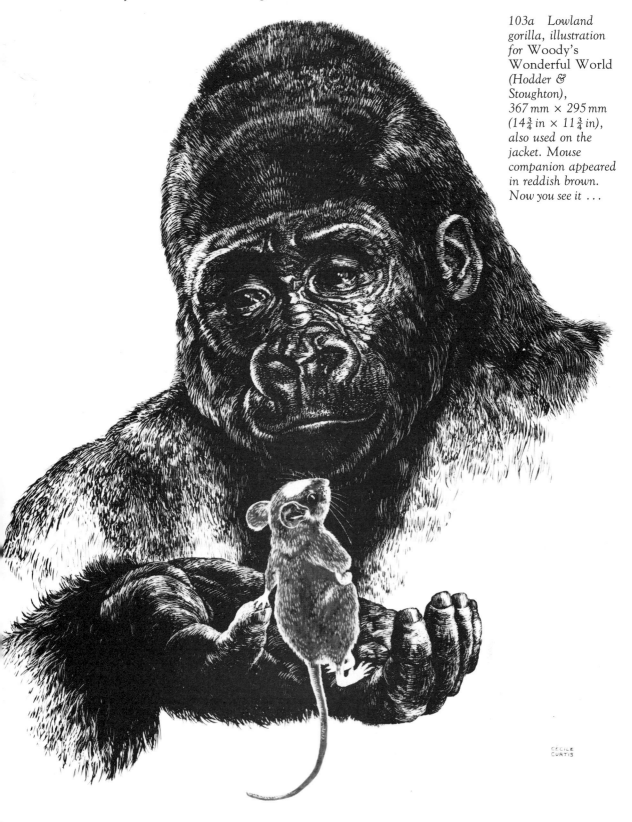

103a Lowland gorilla, illustration for Woody's Wonderful World (Hodder & Stoughton), 367 mm × 295 mm (14¾ in × 11¾ in), also used on the jacket. Mouse companion appeared in reddish brown. Now you see it . . .

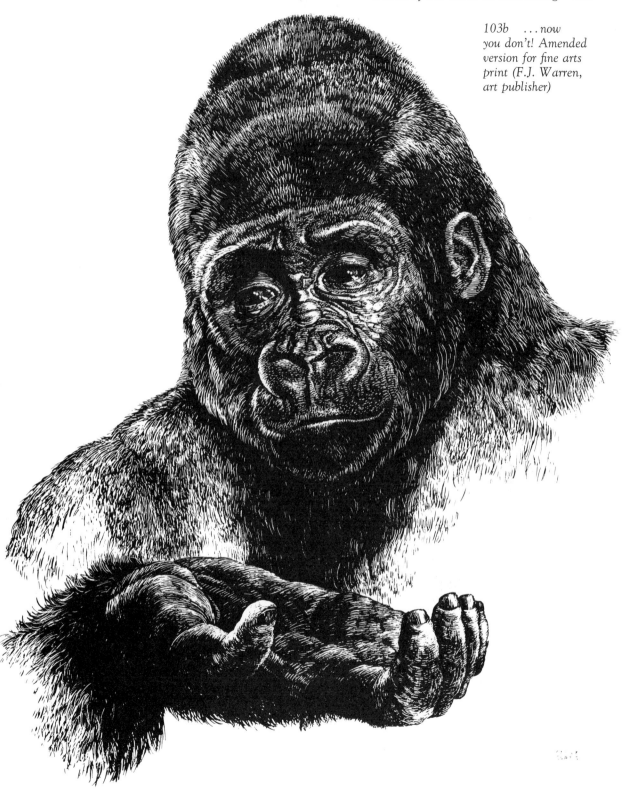

103b ...now you don't! Amended version for fine arts print (F.J. Warren, art publisher)

face, I was utterly fascinated by the look of intelligence and sensitivity in one whose massive form was strangely at odds with his gentle nature. I watched in awe at the skilful way he would retrieve a small morsel of food with seemingly clumsy fingers and was reminded of a case I had read about concerning a chimpanzee with his unusual pet, a baby rat. It planted the seed of an idea for a tale about the largest of all the apes with an even smaller rodent for a pet.

As in the study of the orang-utan, scraperboard/scratchboard offered the perfect means to impart my impression of this truly 'Great Ape' (*103a*). It was on the basis of a brief synopsis and this one illustration, which was ultimately to be used for the jacket as well, that a publisher immediately accepted my first book, to my surprise and pleasure.

It was eventually included in the series of fine arts prints and was also published with the outstretched hand devoid of the tiny companion. I cut a curved, roughly oval-shaped piece of board as an overlay and filled in the missing parts of the palm (*103b*).

Of course, the necessity for such revisions is not apt to be encountered very frequently, but should the occasion arise, it is perhaps reassuring to know that it *can* be done.

8 OTHER USES

Besides the more conventional form of illustration, scraperboard/scratch-board is suitable for a surprising number of purposes. It can be printed very successfully on a number of surfaces such as aluminium, stainless steel, copper, plastics, wood, cloth and china. It has appeared on coasters, table mats, trays, tea towels, articles of clothing, plates and clock faces. A visit to a trades fair featuring gift items will provide endless ideas and outlets for the medium.

Art in industry

My designs for table mats (104) were produced in the same size as the originals done on both black and white scraperboard/scratchboard. They were printed on aluminium and stainless steel in a selection of colours, as well as gold and silver finishes, when reduced to less than one half, for

104 Koala on aluminium table mat (R.H. Technical Industries) measuring 250 mm × 200 mm (8 in × 10 in) in the size of the original on black scraperboard/scratchboard

ANNE HATHAWAY'S COTTAGE
STRATFORD-UPON-AVON

CÉCILE
CURTIS

MADE IN WINCHESTER, ENGLAND

*105 Two
aluminium coasters
from* Scenes of
Britain *series (R.H.
Technical Industries)
measuring
88 mm × 110 mm
(3½ in × 4⅜ in),
reduced to less than
half the size of the
originals, also
reproduced same size
on table mats*

CÉCILE
CURTIS

MADE IN WINCHESTER, ENGLAND

YORK MINSTER

coasters in series of wild life studies and 'Scenes of Britain' (*105*) without
any loss of detail.

 The tray and small dish (*106*) made of Ornamin, a hard, durable plastic,

*106 Panda design
on small dish and
Ornamin tray,
350 mm (12 in) in
diameter (produced
by Praesidium
Products)*

107 Giant panda mother playing with cub, illustration for title page of Panda *(Frederick Warne). 220 mm × 300 mm (8⅜ in × 11¾ in)*

show off these drawings with a great clarity which is retained through countless washings. A decorative treatment of bamboo leaves on the tray was added to this illustration later to adapt it to the circular shape which was printed in green and black on a white background. The company produced other designs of mine featuring stately homes as well as wildlife subjects for specific zoos as souvenirs.

This picture of a giant panda and her cub (*107*), together with others on the same theme, induced a textile manufacturer to commission something similar for a tea towel design in scraperboard/scratchboard (*108*). Because of the difficulties associated with printing on that type of material, it was agreed that my original be *smaller* than the reproduction, which was enlarged to about twice the size. It was the only case I have known where this was necessary, but it proved to be a success and was followed by more wildlife drawings printed on caps, aprons and other articles as well as tea cloths for zoo souvenir shops.

The panda on the tray and the now familiar king penguin found their way onto a children's breakfast set of fine earthenware (*109*), combined

108 Print on tea towel from scraperboard/ scratchboard drawing measuring 350 mm × 260 mm (13¾ in × 10¼ in) enlarged to 530 mm × 410 mm (21 in × 16 in) (Mason Supplies)

SPECIALLY COMMISSIONED DESIGN BY CECILE CURTIS

with part of another illustration from the same book (110). As to this manner of reproduction, I cannot do better than to quote from the Historical Consultant to Spode, Mr Robert Copeland, himself: 'The designs were reproduced by the silkscreen printing process onto special backing paper. When ready for decorating, the transfers were soaked in water and the designs, protected by a thin, transparent film called "covercoat" were slid off the backing paper onto the items of earthenware. All water was "squeegeed" from beneath the transfers which were applied by a fired "glost" wave. The fine red lines were applied by a hand-held brush and the designs then fired on at about 750°C.'

Commemorative medallions

A visit with my portfolio to a company which produced commemorative medallions led to the discovery of an unexpected outlet for scraperboard/

109 Earthenware china children's breakfast set decorated with illustrations from Woody's Wonderful World (Hodder & Stoughton), reproduced by transfer method in black and reddish brown (by courtesy of Spode, a division of Royal Worcester Spode)

110 Illustration for beginning of text from Woody's Wonderful World (Hodder & Stoughton) in which the mouse and clover in foreground were used for the breakfast set

scratchboard. I was commissioned to do various portraits together with appropriate reverse motifs which were subsequently converted to a plaster bas-relief form by means of a sort of three-dimensional pantograph method.

I first engraved the scraperboard/scratchboard portrait in the usual manner. This example (*111a*) of William Shakespeare was created from all that I could find of his few surviving likenesses. Over this went a tracing paper with the required lettering, and it was then reproduced in

111a Scraperboard/ scratchboard portrait of William Shakespeare for commemorative medallion (Metalimport)

111b Plaster cast for Shakespeare medallion

plaster (*111b*) at one of the specialist studios which I later visited in order to make any necessary refinements in the detail before it was minted (*112*).

Two medallions with a common reverse were of Sir Winston Churchill and President John F. Kennedy. I was asked to do several very finished pencil studies of each: Churchill at different ages, both stern and less forbidding-looking versions, as well as smiling and serious portraits of Kennedy. These were carefully shaded with a suggestion of engraved lines and I made a tracing paper overlay of the necessary lettering to fit them. They were then submitted to a committee who were to decide which interpretation they preferred. Their final choices are shown here together with the common reverse and tracings of lettering placed on top (*113, 114 & 115*). After rendering them in scraperboard/scratchboard, they were recreated in plaster and minted in 40 mm (1½ in) medallions of both 22 ct gold and platinum.

112 The author putting the finishing touches to the plaster at an atelier in Paris

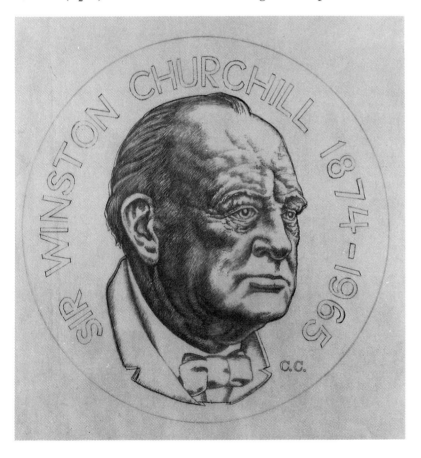

113, 114 and 115 Preliminary pencil studies of Churchill, Kennedy and the common reverse for a pair of medallions (Metalimport)

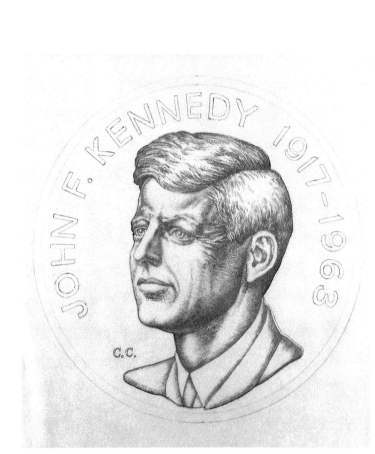

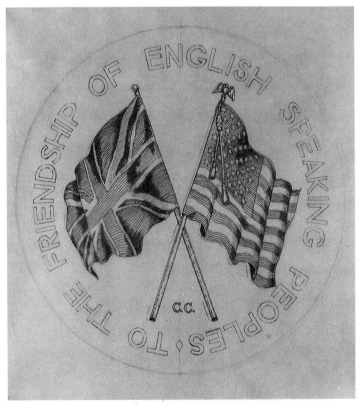

116 and 117
Spaniel and poodle
portraits for
330 mm × 286 mm
(13 in × 11 in)
prints (Entwistles of
Liverpool, England)

Advertising art

The medium of scraperboard/scratchboard still fulfils a definite need in advertising and promotional illustration. Its clarity of reproduction, even on the poorest quality newsprint, makes it a frequent choice to depict a wide range of products.

As a promotional scheme, a dog food manufacturer offered prints featuring different breeds which could be obtained on receipt of box tops from their product. These were on beige, textured paper around 325 mm × 280 mm (13 in × 11 in) and were printed in the same size as the originals (*116 & 117*).

I used a woodcut technique which seemed appropriate for this portrait (*118*) done from an old 'tin type', an early form of photography. My brief from an advertising agency was to produce a likeness that resembled an old print for a bourbon whisky advertisement. Scraping out from solid black, the side as well as the point of a small stencil knife was used. As

118 Scraperboard/ scratchboard portrait using woodcut technique. 153 mm × 124 mm ($6\frac{1}{8}$ in × $4\frac{3}{4}$ in)

Signs of the
Zodiac

119 A surrealist
approach to
advertising art.
335 mm × 217 mm
(13¼ in × 8½ in)

CÉCILE
CURTIS

scraperboard/scratchboard, when properly mounted, is really very tough, I was able to cut out the white areas and broader lines quite deeply, producing a convincing imitation of work on cross-grained wood. Indeed, in the original one can actually feel the grooves in its surface.

Although the technique is more of a classical, wood engraving type, this slightly 'surrealistic' approach to a study of a ram's head (*119*), with steering wheels replacing the horns, was an experiment with an unusual approach to advertising art.

Another unusual concept was introduced in this design (*120*) of the outline of a tuna fish, inside which can be seen a Portuguese fishing village. Not only does the moon serve for its eye, but the sail of the small boat becomes its pectoral fin, while the horizon suggests its lateral line. The original was in sepia ink painted solidly into the carefully-drawn contours. A manufacturer of wallpaper and fabrics was intrigued with this idea of a picture within a picture and asked me to do something similar which would be suitable on the two materials for a dining room or kitchen. I chose the outline of a Spanish onion with an appropriate scene within (*121*). This concept also appealed to the publishers of the James Bond books to use for the promotional poster shown on the front jacket. I was allowed to use a number of colours in a composite picture involving several episodes from the book.

120 Fish design in sepia ink on white scraperboard/ scratchboard. A picture within a picture. 200 mm × 444 mm (7⅞ in × 17¼ in)

121 *Spanish onion design.*
235 mm × 195 mm
(9 in × 7¾ in)

122 *Illustration for promotional material, shown here greatly reduced (Rotamobility).*
290 mm × 410 mm
(11½ in × 16 in)

CÉCILE
CURTIS

This illustration (122) was designed to be used to publicize the work of an organization devoted to the supply and maintenance of wheelchairs as well as other aids and help for the disabled. It had to be clearly visible from a distance in a sort of poster form as well as serving to illustrate explanatory phamphlets etc. Using my husband and our two dogs as models, I planned the composition so that it could be expressed in distinct divisions of dark and light with only limited areas of finely engraved lines.

The Super Realists

There is a special category of scraperboard/scratchboard practitioners who can best be described as the Super Realists. Their work possesses such sparkling clarity and astonishing detail, it defies belief that it was executed by human hands. But indeed it is, and by very patient and skilful ones at that. This method of representation is obviously better than photography, even that of the highest quality, particularly on newsprint where it survives magnificently.

123 Allen Fisher, elaborately-decorated plate interpreted in scraperboard/scratchboard

All manner of products can be expressed in this exacting line technique. Still life, including intricately decorated objects, such as the exquisite plate in this picture by *Allen Fisher* (123), could not possibly have been conveyed with nearly as much success photographically. The clean lines and delicate shading in his drawing of the wine bottle, glass and rose are admirable (124). Notice how the careful cross-hatching of reflected light caught by

the wine in the glass is subtly different from that within the right-hand side of the bottle. The fine, dotted lines on the lighter side of the rose petals and lower part of the wine glass give a nice contrast to the leaves and label.

125 *Philip Gale,
figure of Scots
Guardsman used in
a whisky
advertisement (by
kind permission of
John Dewar & Son)*

This splendid Scots Guardsman in full regalia (*125*) is beautifully
rendered by *Philip Gale* in this illustration for a whisky advertisement.
Shading has been kept to a minimum to give full expression to the various
textures and 'colours' of the uniform. The bearskin hat, tassels of the
sporran and tartan of the cloak and kilt stand out as separate units in a
nicely balanced distribution of light and dark. Where the plaid on the
socks touches the tartar of the cloak, they are still distinct from each
other.

126 *Philip Gale, scraperboard/ scratchboard illustration produced for* A la Carte *magazine*

In the next example by the same artist (126), despite the absence of colour, this tempting dessert really does look good enough to eat! The black area behind it fading to a light tone brings out the form of the objects. The spoon resting on a glass dish, with a distorted glimpse of its handle through the glass stem in front, is a masterly demonstration of technique. At a distance, this could be mistaken for a photograph, and a closer examination might suggest the use of a cross-embossed, black screened board, but, in fact, all of those diagonal lines have been cut by hand.

Effects such as this are often achieved with the aid of a mechanical device called a *haff*. Parallel lines can be cut at any desired angle using a straight edge on a hinge attached to the drawing board. A trigger mechanism is tapped with the finger of one hand whilst engraving with the other in order to space out lines with accuracy and precision to any pre-set measurement. The width of each can be varied to produce shading, their

degree of fineness depending on the size in which the art work is to be reproduced.

The next time you flick through a magazine or newspaper, have a closer look at one of the advertisements where the picture seems to stand out especially well. No, this is not a photograph, it is scraperboard/scratchboard.

I invariably suspect the would-be artist who treats the term 'commercial art' with disdain as being something of a sham. If it can be defined as working specifically to a commissioned order, drawing or painting subjects which are not necessarily of particular interest to the artist but merely to fulfil a requirement, then surely the great masters such as Leonardo Da Vinci and Michelangelo, or Velazquez and Rembrandt must be included in the term 'commercial artist'!

9 FURTHER EXAMPLES

127a An unexpected pose of a giant panda drinking. Sketched from life at London Zoo

127b The finished scraperboard/ scratchboard illustration for Panda (Frederick Warne) 90 mm × 157 mm (3¾ in × 6⅛ in)

CÉCILE
CURTIS

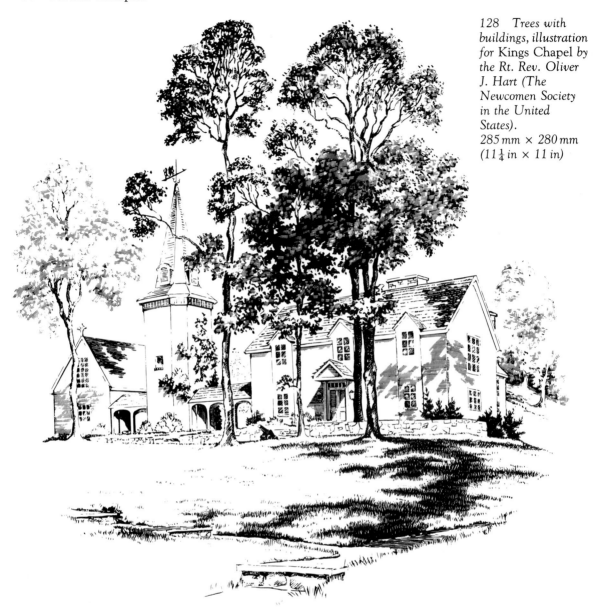

128 *Trees with buildings, illustration for* Kings Chapel *by the Rt. Rev. Oliver J. Hart (The Newcomen Society in the United States).*
285 mm × 280 mm
(11¼ in × 11 in)

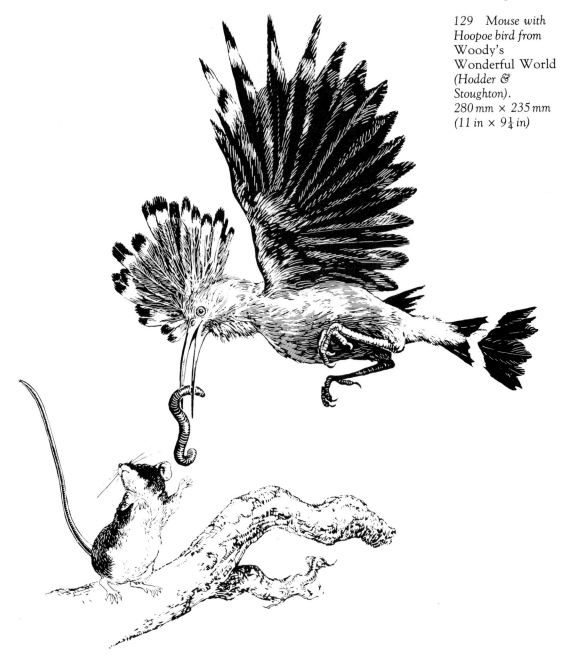

129 *Mouse with Hoopoe bird from Woody's Wonderful World (Hodder & Stoughton).*
280 mm × 235 mm
(11 in × 9¼ in)

131 and
132 (Newcomen
publications)

130 *Personal
Christmas card*

133 *Newcastle,
Delaware,
illustration for*
Woman's Day

134 Illustration for
Two Canadian
Cats *by Peter Dalzel*
(Animals)
365 mm x 270 mm
(14 in x 10½ in)

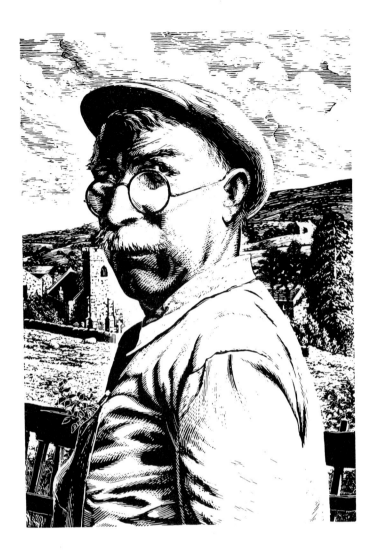

135 G. Lennox
Paterson, Village
Craftsman
illustration on black
board from
Scraperboard
Dryad Leaflet 507
by Anthony Thacker
(Dryad Press)

136 *Illustration on white board from* Electric Power and History in Southeastern New Hampshire *by R.C.L. Greer (The Newcomen Society in the United States)*

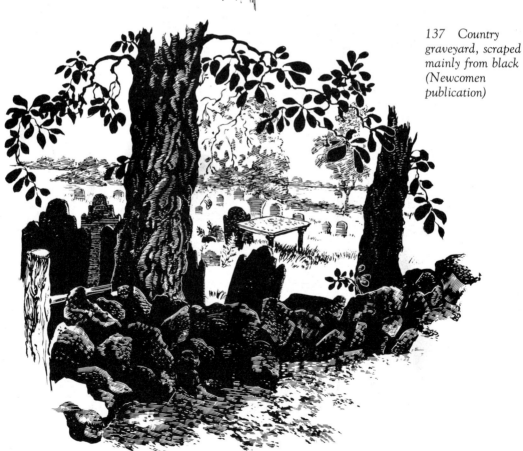

137 *Country graveyard, scraped mainly from black (Newcomen publication)*

138 North American raccoon from Panda (Frederick Warne) in which the animal is scraped mainly from black with pen and ink used for background

139 Anthony Thacker, part of an illustration on black board for Scraperboard Dryad Leaflet 507 (Dryad Press)

*140 and 141
(Newcomen
publications)*

*142 Chapter
separator for* The
Fields of Noon *by
Sheila Burnford
(Hodder &
Stoughton)*

143 *Spot drawing for* You Come Too *by Robert Frost (The Bodley Head)*

144, 145 *and* 146 *(Newcomen publications)*

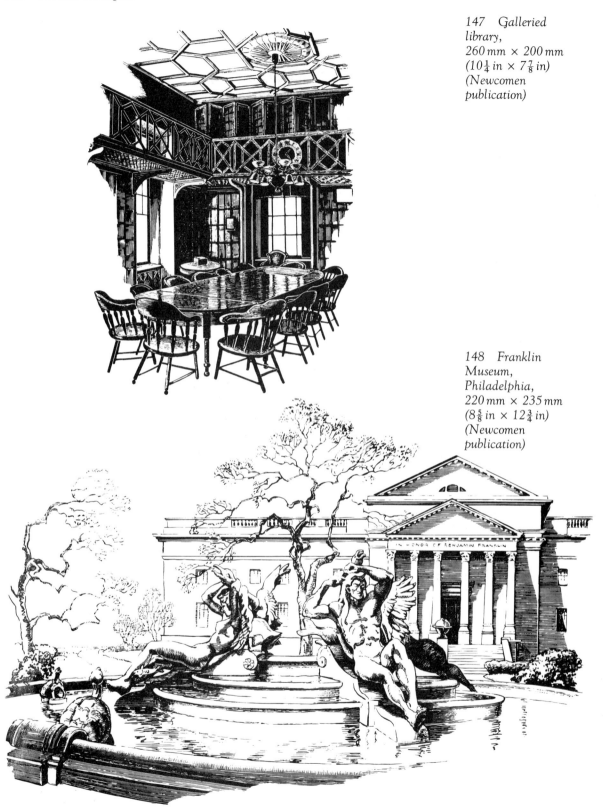

147 *Galleried library,*
260 mm × 200 mm
(10¼ in × 7⅞ in)
(Newcomen publication)

148 *Franklin Museum, Philadelphia,*
220 mm × 235 mm
(8⅝ in × 12¾ in)
(Newcomen publication)

149 *Section of
cathedral with
'Swan' monument,
235 mm × 195 mm
(9 in × 8 in)
(Newcomen
publication)*

150 *South American ring-tailed coati-mundi, illustration for* Woody's Wonderful World *(Hodder & Stoughton), seems as though it is printed crookedly, but, in fact, the animal's weight has tilted the feeding dish!*

151 *Chapter separator for* Chester County Cookery *(Princeton University Press)*

The Dancing Chimpanzee

The
Dancing
Chimpanzee

A study of the origins of
primitive music

152 Jacket design
for book by Leonard
Williams (André
Deutsch). Despite its
title, the publishers
definitely did not
want a chimpanzee
dancing, so I felt it
was imporant to
convey an attentive
expression as though
listening and
vocalizing. Original
on black board,
printed in very dark
blue-green

POSTSCRIPT

Whether your personal aspirations lie in the attainment of such technical perfection as evidenced in the last four illustrations, or you only wish to carry on from the craft kit stage to your own designs, scraperboard/scratchboard is, admittedly, extremely hard work, but it can slso be a great deal of fun.

If the reader, having perused these pages and studied the examples shown, is inspired to invest some time and effort in discovering the satisfaction to be derived from this medium of expression, then this book has served its purpose. I personally have found it a very rewarding one indeed, both commercially and aesthetically, and am grateful for the opportunities offered to me by British publishers and various companies in my adopted country.

None of this would have been possible without the genuine encouragement and very positive help given to me by my late husband, Roy, who was with me all the way. I think it fitting that the final illustration in my text should be this close-up of him.

Roy Curtis (from illustration number 122).

BIBLIOGRAPHY

Scraperboard/scratchboard

Drawing on Scraperboard for beginners Willam Mermode, George Routledge & Sons Ltd, London 1936

Scraperboard Drawings How to do it Series No. 41, C.N. Bacon, M.S.I.A., The Studio Publications, London & New York 1951

Dryad Leaflet No. 164 Scraperboard, G.W. Lennox Paterson, V.R.D. A.R.E., M.S.I.A., Dryad Handicrafts, Northgates, Leicester 1959

How to Cut Drawings on Scratchboard Merritt Cutler, Watson-Guptill Publications, New York, 1st Edition 1949, 2nd Edition 1960

Dryad Leaflet No. 507 Scraperboard, Anthony Thacker, Dryad Press, Northgates, Leicester 1976

Wood engraving and the woodcut

The Graphic Work of M.C. Escher M.C. Escher, J.J. Tijl N.V., Zwolle, Holland 1960 English translation, John E. Brigham, Oldbourne Book Co. Ltd 1961, 2nd Edition 1967

The World of M.C. Escher Edited by J.L. Locher, Meulenhoff International, Amsterdam and Harry N. Abrams, Inc., New York 1971

Der Zauberspiegel des M.C. Escher Bruno Ernst, Taco, Berlin 1978, 1986

The Doré Bible Illustrations Dover Publications, London 1974

The Art of the Print Fritz Eichenberg, Harry N. Abrams Inc., New York and Thames & Hudson, London 1976

The Thames and Hudson Manual of Wood Engraving Walter Chamberlain, Thames & Hudson, London 1978

Portrait of a Country Artist Charles Tunnicliffe R.A. 1901–1979, Ian Niall, Victor Golancz Ltd, London 1980 (wood engraving and scraperboard/scratchboard)
Wood Engraving George E. Mackley R.E., Gresham Books, Old Woking, Surrey 1948, republished 1981

General
The Art of Prehistoric Man in Western Europe Andre Leroi-Gourhan, English Translation, Norbert Guterman, Thames & Hudson Ltd, London 1968

SUPPLIERS

UK

Scraperboard, tools, etc.
Main distributors:

Daler-Rowney Ltd
P.O. Box 10, Bracknell
Berks RG12 4ST

Reckitt & Colman Leisure Ltd
P.O. Box 91, Wealdstone
Harrow, Middx. HA3 5QN

Retail outlets:

Fenwich Dryad
Market Street
Leicester

Fielders
54 Wimbledon Hill Road
London SW19 7PA

Kemp & Co. (Victoria)
28 Buckingham Palace Road
London SW1W 0RE

Reeves Dryad
178 Kensington High Street
London W8

Winsor & Newton
24 Rathbone Place
London W1

Craft kits (at most of the above and
 the following chain stores)
Allders
Fenwicks (Brent Cross & Newcastle
 upon Tyne)
Harrods
Lewis Department Stores
 (Xmas Season)
Selfridges (Oxford St.)
Zodiac Toys

Wood engraving multiple tools
Dryad
Northgates
Leicester LE1 4QR

T.N. Lawrence & Son
Bleeding Heart Yard
Greville Street
London EC1N 8SL

USA

Scratchboard, tools, etc.
Main distributors:

Arr-Jay Productions
9440 N.E. 26th
Bellevue, Washington

The Morilla Co. Inc.
211 Bowers St.
Holyoke, Mass. 01040

Craft kits
Main distributors:

Brittoys

Wood engraving multiple tools
Edward C. Lyons
16 West 22nd St
New York, N.Y. 10010

INDEX

Numerals in italics refer to page numbers on which illustrations occur.

advertising *121–129*
aluminium, reproduction on *111–112*
architectural detail *36, 76, 90–92, 94–96*
aurochs *63, 64, 67–70*

Bacon, C.W. 20
bat, Indian fruit *98–99*
Bewick, Thomas *13–14*
Bond, James 123; front jacket
British Process Boards 17, *28*
buildings *39–40, 50–55, 89, 112, 132, 135, 142–143*
burin, 'parrot-beak' 63, 69

Cape buffalo *102–103*
cast shadow *90–96*
cat *136*
chimpanzee *145*
china, reproduction on 114, 116
Churchill, Sir Winston *118*
coati-mundi *144*
Cole, Walter 19
colour, use of *79–87*
Copeland, Robert 116
craft kits *9–10, 26–27*; colour plate 7
crane, crowned 80; colour plate 1
Curtis, Roy *124, 147*
Cutler, Merritt 19

deer *14–15,* 63, 69
Dickson, David 17
dog 41, *71, 74–77, 120–121, 124–125*
Doré, Gustave *14–15*
drawing, preliminary *63–64, 71–72, 131*
Dufex 34, 38, 44; front jacket
Dürer, Albrecht *12–13*

Eichenberg, Fritz 9, 11, 19
eider duck *43*
elephant, African 17, *100*
Escher, M.C. 18
experimentation 20, 22, 28, *85–87*
extensions *105–107*

fish *98*
Fisher, Allen *125–126*

Gale, Philip *127–128*
giraffe *97*
goat *82–83,* 85
gorilla, lowland *106, 108–110*
greetings cards 17, *30, 44*

haff *128*
half-tone 9, 28, 63, 87
Herbert, Stanley 20
hoopoe *133*

ink
 black, Indian *24–25*
 coloured 80, *85–86*
interiors *39, 40, 59–62, 78, 104, 134, 142*
jackets, designs of *79–81, 84–85, 89, 108, 110, 145*; colour plate 6

Kennedy, John F. 118, *119*
koala *111*
Kumme, Walter 19

light, importance of 29, 41, 42
lion *37–38, 41–42*; colour plate 5
Lucas, James 20

mammoth *11*
Maugham, Somerset *45–46*
medallions, designs for *116–119*
mouse *33–34, 97–99,* 105, *117, 133*
Muller, E.C. 24

novella 98

orang-utan 86; back jacket
overlays 105–110
owl *19*

Paleolithic art *11,* 63, *69*
panda, giant *93,* 113–116, *131*
pen and ink technique 24, *38,* 59–60, *80, 93,*
 100–101, 109
penguin, king 105–*107*
pens, technical *23–25*
plastic, reproductions on 112–114
porcupine, giant crested *101*
portraiture *29, 45–49,* 117–119, *147;* colour
 plates 2,3,4
Poulton, T.L. 20
psychology of composition *48–49, 96–100*

raccoon, North American *139*
ram *122–123*
reproduction
 half-tone 9, *13–14,* 28
 line 9, *14,* 16–17, *85,* 88–89, *128*
reproduction on
 aluminium *111–112*
 china 114, *116*
 linen 114–*115*
 medallions 116–119
 plastic 112–114
rhino 31, *33–34*
rocks *43, 59*
Ross board 17
Ross, Charles H. 17

seagull *136*
scraffito 13
scraperboard/scratchboard
 Austrian 9
 black 21, *63–70*
 sizes 21
 textured 21, *43–44*
 white 21, *71–78*
Shakespeare, William *117*
Simons, Arthur 17
Society of Wildlife Artists 86
squirrel *30–31*
Surrealism *122–124;* front jacket
swan *79, 84,* 86; front jacket

tea towel, reproduction on 114–*115*
texture 30–31, 34, 37
tools
 burin 63, 69
 engraving 22–24
 multiple 23, 28, *37–38,* 40–41, 46, 89
tracing 25, 66–*67, 73, 77*
trees 46, *56–59;* colour plate 3
trompe l'oeil 18
Tunnicliffe, Charles 18–20, 43

Victorian London 42

widgeon *20*
wildebeest 80; colour plate 1
wood engraving 9, 13, *14, 19*
woodcut *12–14,* 18
 technique 88, *90–91, 121, 123*

zebra colour plate 1
zinc etching 14, *16*
zoo
 London 31, 86
 Philadelphia 38
 souvenirs 114